DOODLE ART & LETTERING

WITH JOANNE SHARPE

Inspiration and Techniques for Personal Expression

NORTH LIGHT BOOKS
CINCINNATI, OHIO
www.artistsnetwork.com

CONTENTS

DEDICATION

This book is dedicated to every single one of my whimsical students all over the world who have blessed me and trusted me with their creativity. To those sassy, playful, kind, happy souls who make art with me my online classes and in-person workshops: You inspire me every day to keep innovating and making new art experiences for you as your friend and teacher. You can't overdo a doodle, and you can't overdo the love, energy and enthusiasm that comes from all your art friends

MATERIALS LIST OVERVIEW

Don't feel like you need to have all of these products in order to start creating. Begin with the materials you already have or the basic necessities: a few pens, markers, paint, paper and brushes. Then, as you progress through the book, add a few new materials as they strike your fancy. Pretty soon you will know what suits you and where your passions lie, and you'll have the tools and materials you need to follow your doodling dreams.

PAPER

ART JOURNAL OR SKETCHBOOK (SUCH AS MOLESKIN OR STRATHMORE VISUAL JOURNAL)

BRISTOL PAPER

HEAVY WHITE PAPER

INDEX CARDS

TRACING PAPER

VELLIM

WATERCOLOR PAPER

PENS

ASSORTED BLACK PENS, PERMANENT AND WATERPROOF WITH A VARIETY OF TIPS, INCLUDING THICK, THIN, BROAD AND CHISELED (MICRON, PITT, ZIG, UNIBALL, SHARPIE, PAPERMATE AND PLATINUM ALL MAKE GREAT PENS)

GEL AND METALLIC/SPARKLE PENS (A WHITE GEL PEN IS A MUST—THE UNIBALL SIGNO UM153 IS A GOOD CHOICE)

COLORED PENCILS

A VARIETY OF COLORS TO SUIT YOUR NEEDS (PRISMACOLOR AND POLYCHROMOS ARE TWO RECOMMENDED BRANDS)

PENCIL SHARPENER

ART MARKERS

ACRYLIC PAINT MARKERS

ALCOHOL-BASED PERMANENT MARKERS SUCH AS COPIC, PRISMACOLOR AND SHARPIE (ALCOHOL-BASED MARKERS WILL BLEED THROUGH MOST PAPERS)

DYE-BASED MARKERS SUCH AS ROMBOW AND KOI BRUSH (DYE-BASED MARKERS ARE WATER REACTIVE)

WATERCOLOR PAINTS AND BRUSHES

A SET OF WATERCOLOR PANS OR TUBES

LIQUID WATERCOLORS

MICA-INFUSED OR METALLIC WATERCOLORS

WATERBRUSH (THE NIJI WATERBRUSH AND PENTEL AQUABRUSH ARE BOTH GOOD BETS)

WATERCOLOR ROUND BRUSHES IN SIZES #4, #8 AND #12

WATERCOLOR SPRAYS

ACRYLIC PAINTS

FINE-TIPPED PAINTBRUSHES

FLUID ACRYLIC PAINTS (SUCH AS GOLDEN)

DIMENSIONAL PAINTS

DIMENSIONAL CRAFTPAINTS IN A VARIETY OF COLORS, 3-D, METALLIC, GLITTER, SATIN (BLACK, WHITE AND GOLD ARE GOOD ONES TO START WITH)

OTHER SUPPLIES, MATERIALS AND TOOLS

BINDER RINGS

COMPASS

DYLUSIONS SPRAY INKS

ERASERS

FRENCH CURVE

GLUE STICKS

HOLEPUNCH

MOLOTOW RESIST PEN

PENCILS

SCISSORS

SPRAY BOTTLE

STENCILS

T-SQUARE

WASHI TAPE

WATER CONTAINER

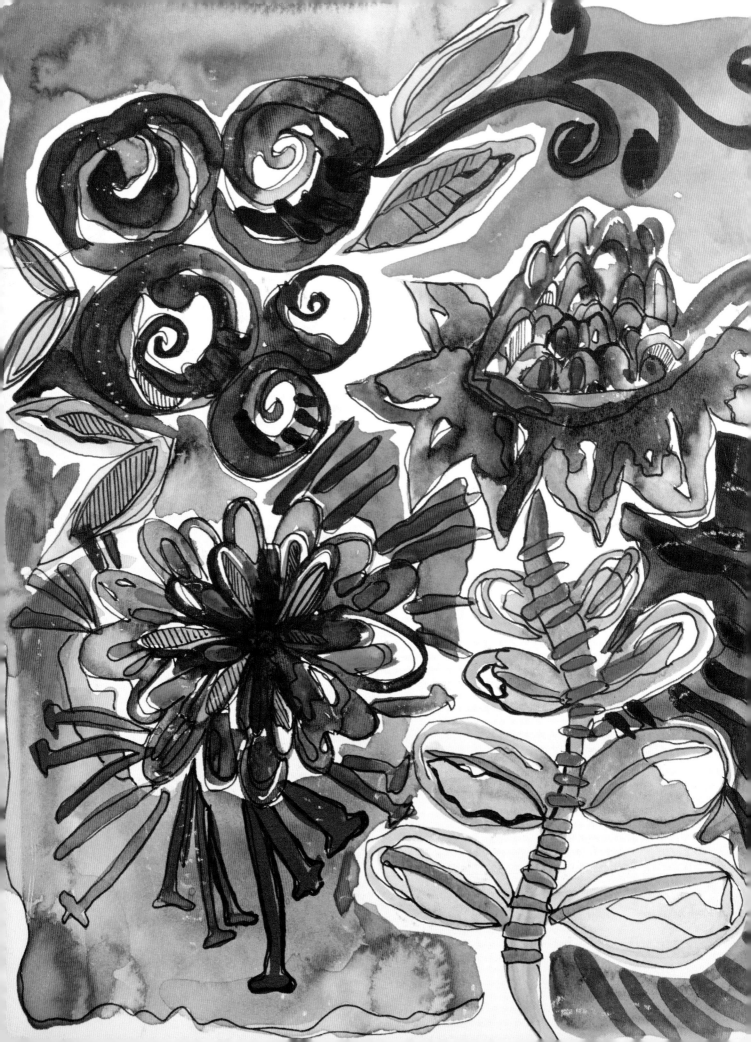

INTRODUCTION

Doodle. It's such a funny word!

It immediately inspires a smile or giggle. Just the sound of the word tells the brain to let loose, head off into playful space for mental fun and frolic. Doodling can also be more intentional—a stress relieving activity, or even a meditative, mindful spiritual practice. The art of the doodle can be as simple or as sophisticated as one chooses.

How is doodling defined? It can have different meanings to individual personalities, some more serious and scientific or playful than others. I choose both. You don't need an art degree to be a good doodler, as it's an activity for any age, often requiring nothing but a free spirit and some very simple tools. It's a learning tool that helps increase focus and information retention. It's not scribbling or writing unintentionally, but rather it's making marks and movements using basic art techniques and principles to create a visual response. Doodling can be a personal, creative art expression, or it can serve as a therapeutic mental and physical practice for an expected outcome of serenity or gratification.

Why doodle? It's good for your soul and spirit! This all might sound like unnecessary, frivolous activity, but the practice of doodle art does have merit and health benefits, especially in our current tech-driven society. There is an abundance of scientific and social research that exonerates doodling as a essential activity to fulfill human beings' need to connect to the world with tactile and visual experience. Doodling is the limitless drawing activity that stimulates movement in the mind by making art forms with expressive, loose moving line, repeating patterns, elaborated shapes and simple imagery, organic or geometric form, in black and white or color.

Throughout this book I will show you drawing and art making practices and activities in a doodling style that will catapult into fabulous personal artworks. Doodle drawing is a nonthreatening, necessary skill and discipline in the creative process. The repetitive motions that move line, shape and pattern from your brain to your hand to your surface creates muscle memory for future drawings and paintings. Now turn the page, put on your doodling shoes and go doodle your art out!

Joanne Sharpe

TOOLS OF THE DOODLE

PAPER
I create daily in a journal or sketchbook, keeping my body of artwork in book form. The surfaces of these journals and sketchbooks use heavy white paper or watercolor paper by brands like Moleskine and Strathmore Visual Journals. Individual art is also done on assorted papers like bristol, watercolor or vellum paper. Choose what works for you.

PENS
I believe that you can never have too many shoes or pens! I have dozens and dozens of pens. There are so many to choose from that do so many different things. I am often asked which is the best pen and which is my favorite pen. But I really can't answer that, because there are so many variables. I like pens, so I'm not the best person to ask. I am always willing to try different pens and markers. The best advice I can offer is to stock your supplies with assorted black ink pens, permanent and waterproof pens, and with a variety of tips that are thick, thin, broad and chiseled. Some of my favorite brands are Micron, Pitt, Zig, Uniball and Sharpie.

COLORED PENCILS
Colored pencils are a must for making colorful drawing art. Choose the brand that fits in your budget and try different pencils to discover your favorite. I personally use Prismacolor and Polychromos brands.

ART MARKERS
Whether you are making art on paper or in an art journal, a rainbow of colorful markers is essential. It's good to have two types of markers: alcohol-based and dye-based. Alcohol-based markers like Copic, Prismacolor and Sharpie are permanent and will always bleed through paper. Dye-based markers like Tombow and Koi Brush pens will react with water and can even be used to create watercolor-painted effects. Acrylic paint markers are another excellent tool to for making bold, opaque, permanent marks in art. Try different brands to see what fits your style. Even school-grade brands of markers and pens are fun to try.

WATERCOLOR PAINTS AND BRUSHES

I doodle with pens and paints. Watercolor paints and spays are go-to mediums in my artwork. Purchase a pan set of pre-selected colors, or make a your own palette with tube watercolors and empty pans. Watercolors can be as affordable or pricey as you choose. A visit to an art supply store with knowledgeable staff can help you decide which brand and quality fits your needs and budget best. Try liquid watercolors or sprays, as well as mica-infused paints.

Try drawing and doodling with a waterbrush with your water-color paints . This is a handy tool with a water-filled reservoir that allows you to squeeze tiny bits of water into paint and move it around on a paper surface. Niji and Pentel Aquawash are my favorites. I also use watercolor round brushes #4, #8 and #12 for doodling in watercolor.

FLUID ACRYLIC PAINTS

Use a fine-tip brush to draw with acrylic paints. Since much of doodling involves repeating patterns and line work, I use fluid acrylic paints. Fluid acrylics are heavier than watercolors and inks but thinner than regular acrylic paints. They can be easily manipulated for doodle drawing and line work.

DIMENSIONAL PAINTS

Experiment and play with crafty dimensional paints. These usually have a thin tip cap, are easy to draw with, and dry with raised lines. They come in 3-D, metallic, glitter and satin looks.

A TOOLBOX

Other items you'll want to keep handy when making doodle art on paper or in a journal or sketchbook include: scissors, erasers, pencils, a compass, a plastic T-square, French curves, washi tape and glue sticks.

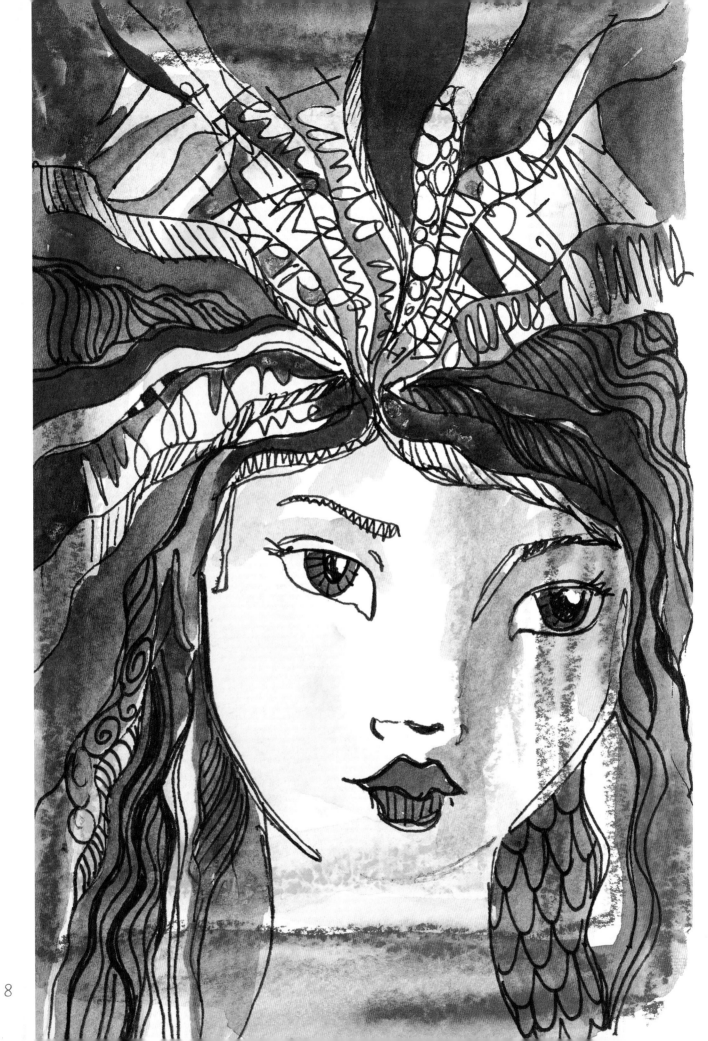

① Just Doodley Do It

Let's start your doodle art journal. There's usually a little hesitation, some fear and a stalling session when one ventures into new creative territory. We wonder if our attempts will be good enough and if they will compare to the samples of the process provided by the teachers or artist's work from which we are finding inspiration. The truth is, the first time or at the beginning of your foray into drawing and lettering, your art attempts are probably going to be comparable to playing *Twinkle, Twinkle, Little Star* as if this was your first piano lesson. It will take practice to gain confidence in this expressive art and get comfortable with making smooth and effortless looking letterforms. And when I say it will take practice, I mean practice every day. I have is an art journal or sketchbook at my side every single day and I make sure take at least five minutes to put something in the book. Even if you are stealing just a few moments or minutes, you need to put pen, pencil, marker or paint to paper every day.

Most likely there won't be a masterpiece born in every daily attempt, but these ideas, sketches and efforts are stepping stones to developing your style and igniting your passion. Train your mind to spill out art elements through your hand, and elaborate and transform basic line, shape, pattern and color to make your own personal expression. Whether you chose to make abstract or realistic imagery, there is freedom in making doodle imagery with the expectation of finding perfection in imperfection. Decide if your art-and-letter making is just for you or if it's to share, show or serve as a personal de-stresser that frees you from the frazzled moments of a crazy day.

Crack open a journal or sketchbook and start to play on the fifth page. Not the first four pages. It seems we are always petrified to put something on those first few pages of a yummy new sketchbook. So don't. Start instead on the fifth page. Draw something anything. Or write words. Write exactly what you are thinking as you stare at the blank page. Find your own voice. Let go. Let loose and just doodley do it!

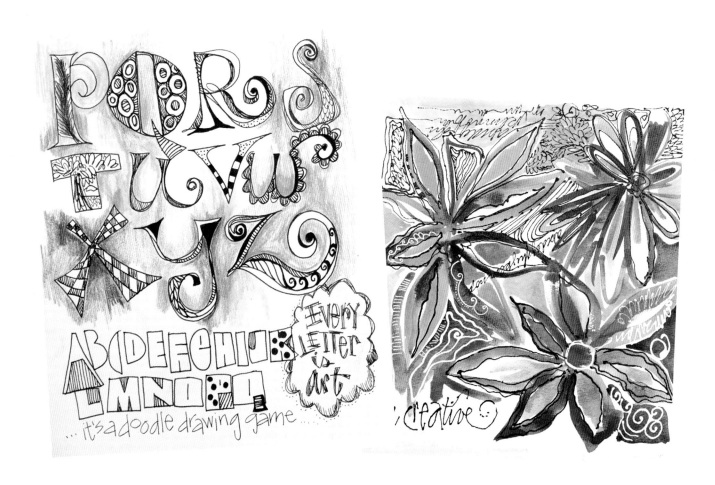

WHY DOODLE?

Why do I doodle? When I critique my own art I ask myself, "Why is my personal artwork abstract, loose, spontaneous, random, patterned, overloaded with every color I could possibly use?" Because it makes me happy. It helps the things that exist in my imagination become visible. I love color, I love letters. You have to find the things you absolutely love and put them into your doodle art. In my personal opinion, there really isn't a huge difference between drawing and doodling, because when you doodle, you are drawing. I like to think about doodling, as "drawing without the rules," because my end result is not a photographic rendering of objects or a scene, but I use the same art principles to make my abstract expressive art.

This whole drawing practice revolves around building, adding, layering, changing and repeating with your pen or brush in constant motion. In my journals, I can spend as much time as I want, adding more and more pieces to each page. What I love about this process is that you "can't over do a doodle!"

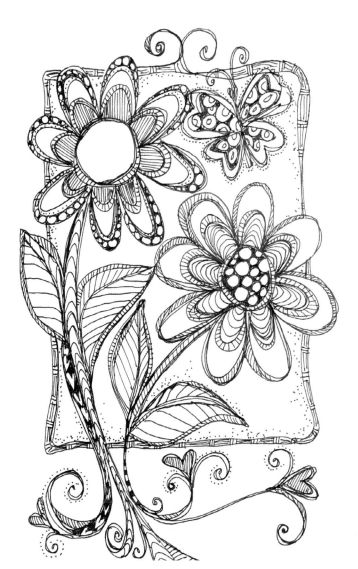

DOODLE BENEFITS

What benefits are there in creating doodle art? I find that my loose and freeform doodle art is relaxing, plain and simple. It is mindful and meditative, coming from my own thought and power. For me, there is calm and an overarching peacefulness in letting the pen slowly skate across a page. To achieve this bliss, I usually have no other intention than to just make simple images, lines and patterns while writing thoughts that pop into my head as I draw.

Some things have to be BELIEVED to be seen

it's time

one day you just woke up in the sunshine and decided to have the courage to change everything

GET IN THE DOODLE ZONE

Now that you have planted yourself in a brand new journal or sketchbook, it's time to "fly, create, play." Make it a point to get in that "zone" daily, that place where you will let your pen or brush make visible whatever is in your head. Keep your journal visible and easily accessible. Put your favorite pens and markers in a cup or designated pencil case for quick access. Allow yourself as much time as you can afford—even if it's just a few minutes. Schedule the doodle moments into a convenient part of your day when you know you will have a specific amount of time to doodle draw or make lettering art. It can be any time of the day as long as it is some time every day. That's how you get really good at all this. It should never be a chore, so get excited about putting pen to paper and see what doodle art and words flow onto the pages.

Here's what I find magical about making doodle arts and lettering. You must start creating art with line and shape on each page in your journal with no end result in mind. It's always about just making a mark and seeing where it leads. There are several simple ideas that jumpstarted each of the journal pages here. Try them in your own journal.

- With a black pen, go directly onto the page and make horizontal lines across the top half of the page. Fill in the resulting rows with tiny drawings and repeating patterns.

- Make vertical lines in the same fashion and fill them in with pattern as well.

- Leave larger wide open spaces for words, phrases or lettering.

- Find inspiration in nature and fill your page with a tree that stretches the entire height and width of the page.

- Use a repeating shape, like circles, and fill in each with a different pattern or motif.

- Color in black and white drawings with markers or colored pencils.

- Use a pen to draw a repetitive motif, filling in each part with multiple patterns and words.

- Get really brave and draw with a brush and black fluid acrylic, making loose flower petal and leaf shapes.

- Doodle and decorate your colorful painted art with a white gel pen.

IDEA LIST: THINGS TO DOODLE

So now that you have decided to make this epic doodle journal, just what should you doodle, draw and letter? You still will be drawing and lettering things, but with a more stylized flair, more whimsy, with less realism and more fun. Designate entire pages for themes, scenes and doodle arts and letters and make it a daily practice to complete the entire page. Don't worry about being super realistic, just focus on capturing the essence of your message with line, shape, words and color.

30 DAYS IN YOUR DOODLE JOURNAL

Use this idea list as a personal challenge to complete a daily doodle drawing using pens, markers, colored pencils and watercolors. Make simple art imagery on the pages and add words and journaling to the page layout. Use your personal photos or search for inspirational photos and images.

1. a whimsical face
2. letter a mantra
3. imaginary flower blossoms
4. floral bouquet
5. palm trees
6. candy
7. tree bark
8. a favorite song
9. a beach scene
10. flower garden

11. butterflies
12. birds
13. fruits
14. vegetables
15. coffee or tea cups
16. cupcakes
17. fish
18. cloud forms
19. shells
20. cats or dogs

21. leaves
22. botanicals
23. jewelry
24. hearts
25. shoes
26. a dream
27. feathers
28. a hairdo
29. breakfast
30. alphabet

WHAT TO DOODLE? LIST IDEAS ...

Here is a "Doodle Daily" idea page directly from my journal. You can doodle everything. Make simple line-art doodle drawings of everyday objects. Seek simple or elaborate imagery. Develop your own style, capturing the essence of your favorite things. Make up your own illustrated list in your journal or sketchbook.

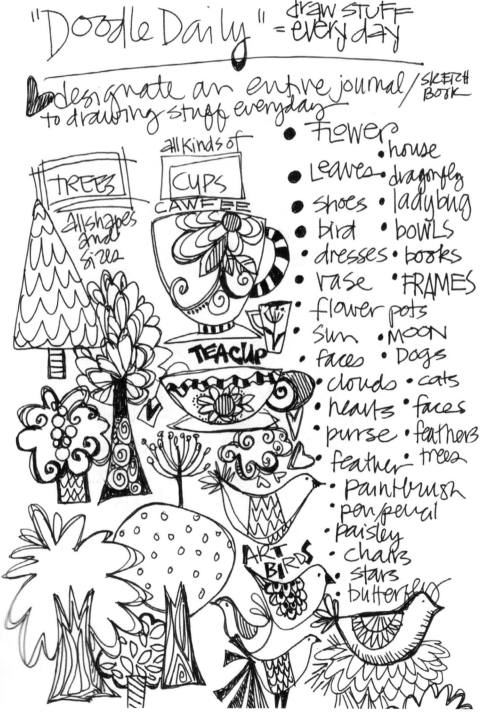

"Doodle Daily" = draw stuff every day

designate an entire journal/SKETCH BOOK to drawing stuff everyday

TREES
all shapes and sizes

all kinds of CUPS
CAWFEE
TEACUP

ART BIRDS

- FLOWER
- house
- Leaves
- dragonfly
- shoes
- ladybug
- bird
- bowls
- dresses
- books
- vase
- FRAMES
- flower pots
- sun
- MOON
- faces
- Dogs
- clouds
- cats
- hearts
- faces
- purse
- feathers
- feather
- trees
- paintbrush
- pen/pencil
- paisley
- chairs
- stars
- butterfly

TOOLS TEST

Gather your pens and markers to explore and discover the effects you can achieve with different brands, styles and qualities. There's no need to spend a ton of money on fancy pens when there are plenty of simpler, less expensive tools that can yield the same results. As a single-page reference section in the back of my own journals, I test the performance of all my pens and markers. It's amazing how different some of these tools work, and it affirms to me why I can never answer the question "What's the best pen to use?" Each pen has its own special characteristics, and I do find that I end up using all of them.

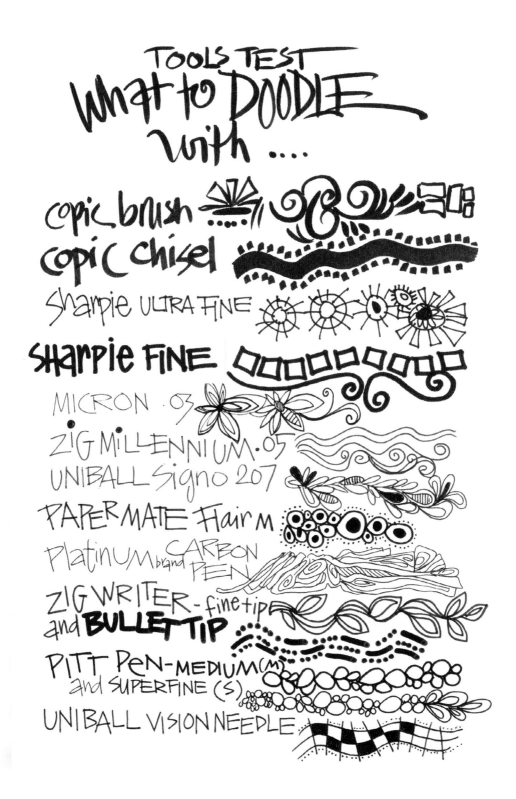

DOODLING TOOLS

You'll want to have a good variety and assortment of pens, markers and paintbrushes to make doodle art. Gather all your supplies and make a sampler page of each one. Just draw anything to see what works best for you as you doodle away.

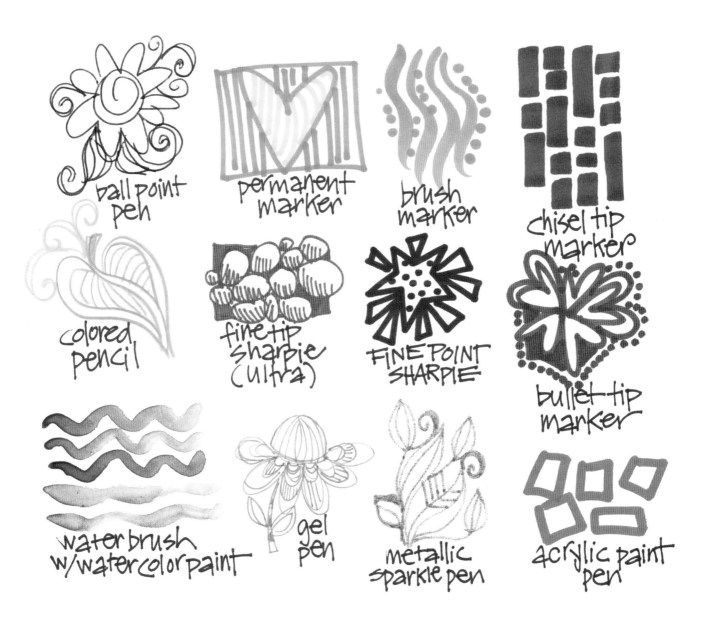

ball point pen

permanent marker

brush marker

chisel tip marker

colored pencil

fine tip Sharpie (ultra)

FINE POINT SHARPIE

bullet tip marker

water brush w/watercolor paint

gel pen

metallic sparkle pen

acrylic paint pen

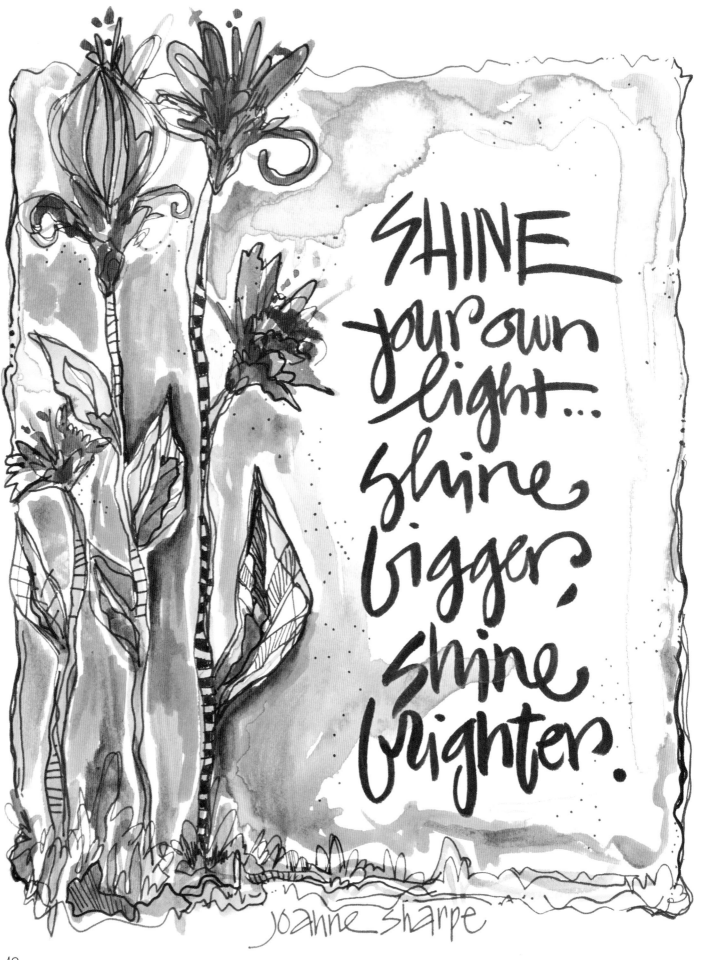

SHINE your own light... shine bigger, shine brighter.

Joanne Sharpe

2. Make Happy Art

While teaching an adult doodling art workshop recently, I was asked, "Why do you do you make all these journals, and what do you do with all the art you make?" This student was concerned because she was in the process of downsizing her life and informed me that she didn't need any more "stuff." I was caught off guard a little bit, because in the moment I didn't have an answer, and I thought, "Doesn't everyone like to make art and have piles of it all over their house?" I finally told her that I make art for my sanity and pleasure and that someday it will be my legacy—a reflection of how I responded to my life.

To me, making art, especially in a journal or sketchbook, is essential to who I am. Yes, I am an artist but also just an ordinary someone living an awesome life. Not everyone needs to share this obsession, but I personally need my art practices to be a part of my daily routine. With pen, markers or paints in hand, I approach a blank page daily to create, just like each day presents its own blank page. And what do I do with all my journals and artwork? I love them! I do have mountains of books and portfolio cases filled with loose art, and I look at them often. They are filled with words and writing, scribbles and messes, masterpieces, thoughts, brainstorms, and play. It's a privilege to look back and see how my life and art has changed and to remember events and emotions in a visual form. These colorful art books and pages tell my life story.

The art journal is where I make my "happy art." The joy comes from creating and expressing myself with a visually documented record of my thoughts and life's journey. I believe human beings should make any kind of art to their spirit visible.

ILLUSTRATE SIMPLE IMAGERY

You don't have to be a trained professional to make art! You're allowed to respond to your life creatively and discover what secret talents or passions might be lurking inside you. Grab a few art supplies, find your happy place and doodle to just doodle, draw to just draw and paint to just paint. Don't worry about what results will look like. If you can write your name, you can draw. Move your pens around in the same motions, just turning lines and shapes into recognizable images. Look at what surrounds you, and draw that coffee cup or pair of shoes. Or fill a small page with colorful painted lines just for the sake of making.

I enjoy making little watercolor-paper accordion journals filled with simple, tiny drawings of my favorite themes, shapes and images. They're small in size and give me the opportunity to make art—even if for just a few minutes—without feeling overwhelmed. Sometimes the pages are just randomly painted with a waterbrush, with handwritten words scattered in the repeating lines. In any event, I always find contentment in the process and just paint to paint.

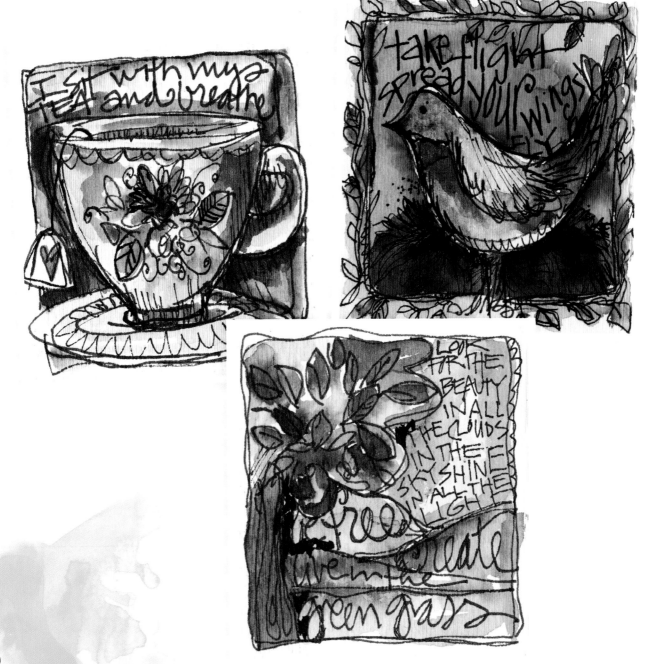

What are your favorite things? Which favorite images might become themes in your own art? As you can see by the samples of my art in this book, I love to draw and doodle hearts and flowers (lots of flowers!), simple faces, and organic shapes and patterns found in nature. There is a great freedom and energy that comes from this style of doodle arts and lettering because you can be as playful or as serious as you wish. My art is defined as whimsical and expressive. This style comes naturally to me, and I typically struggle with making super realistic drawings or paintings.

The same is true for lettering art. My lettering is not formal calligraphy but rather my own artful interpretation of the alphabet. You are making authentic art when you are comfortable in a style, when it comes easily, and when you are not trying to replicate the look of art created by someone else. Find the things that excite you and that easily flow from your soul onto the paper as you doodle, draw, paint and letter.

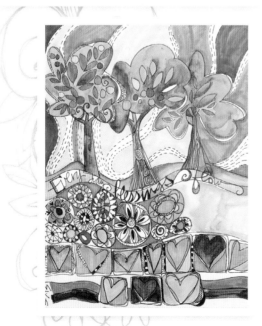

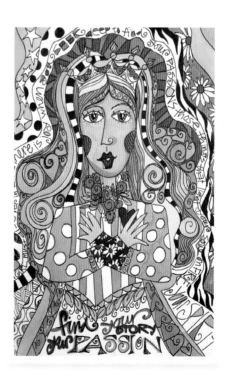

SHAPE

This example—right out of the pages of my sketchbook—demonstrates the technique of starting off with super simple basic shapes and turning them into doodles and patterns. Once your mind starts working out the endless possibilities of adding and building as you draw, you'll have an infinite supply of ideas.

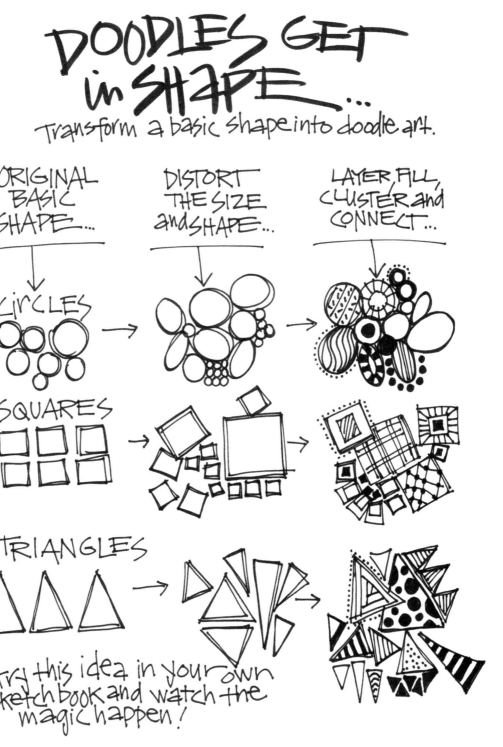

DOODLES GET in SHAPE...

Transform a basic shape into doodle art.

ORIGINAL BASIC SHAPE...

DISTORT THE SIZE and SHAPE...

LAYER, FILL, CLUSTER and CONNECT...

★ Circles

★ SQUARES

★ TRIANGLES

★ Try this idea in your own sketchbook and watch the magic happen!

HOW TO INCORPORATE SHAPES INTO DRAWINGS AND PATTERNS

Shape is the essence of doodling and lettering. Make shapes that originate in the basics and elaborate, cluster and decorate them as you insert them into a composition. Be mindful in the placement of your shapes, but don't overthink the need to create something literal or recognizable. The appeal is in the random arrangement of shape.

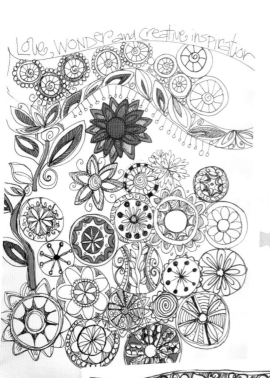

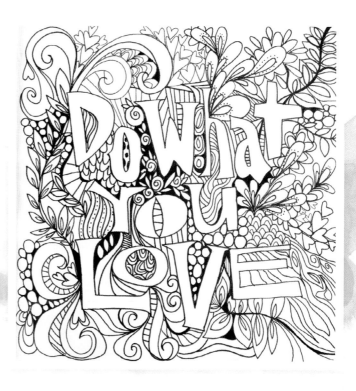

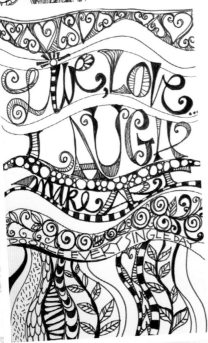

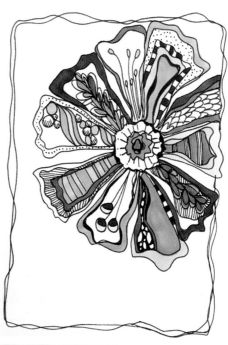

LINE

So much of my expressive artwork is rooted in linear form. Visually, everything in our existence is defined by line, whether straight or shaped. If you look up from this page and observe everything around you, you'll see that everything has line. Look at the shape of a doorway, window frame, chair—everything in view. Every single object has a straight or curved or moving line.

Think about this principle in doodling, and use various line forms to form new images. Lines can be manipulated into formation, creating echo patterns, dimension, movement and even shapes that change the identity of the original line.

Draw boxes in an art journal with decorated lines to add words and hand lettering.

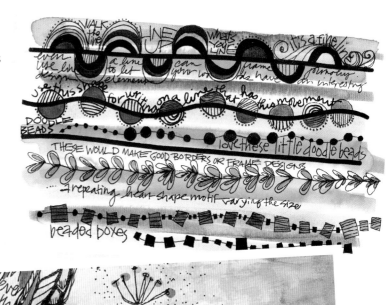

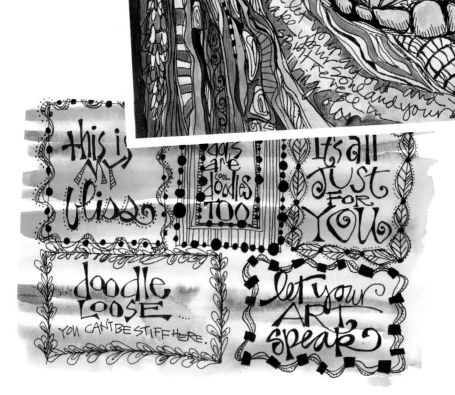

Creative Doodle
LINES

the doodle is all about LINE... all kinds
of line that gives movement to art.

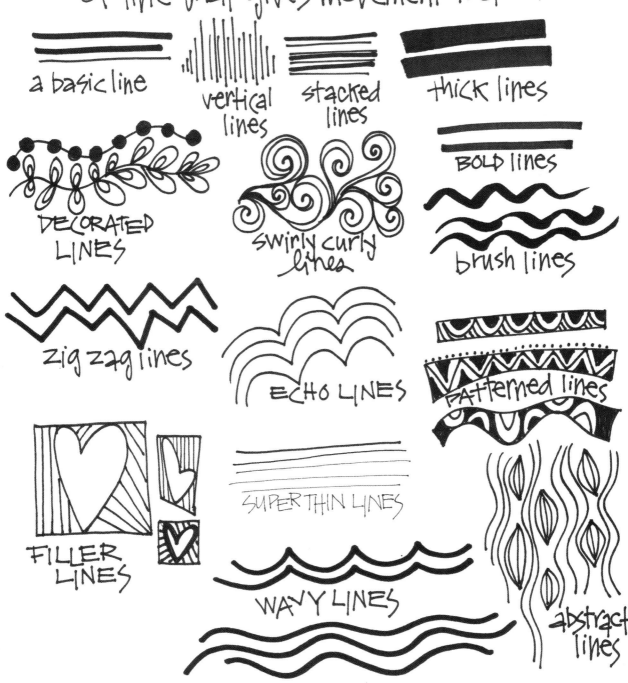

a basic line

vertical lines

stacked lines

thick lines

DECORATED LINES

swirly curly lines

BOLD lines

brush lines

zig zag lines

ECHO LINES

Patterned lines

FILLER LINES

SUPER THIN LINES

WAVY LINES

abstract lines

PATTERN PLAY

It's a great challenge to design your very own doodle patterns, whether they come straight from your own imagination or are inspired by nature or your own surroundings. Do you think you can come up with one hundred different patterns without repeating any of them?

A helpful tool in developing ideas for pattern is to use a designated sketchbook or journal to experiment and strengthen your drawing skills. Sketch out two pages for drawing, and work across the entire two-page spread. Draw a variety of different sized boxes with a pencil, arranging them to fill the pages. Paint or color each box with markers or watercolor. (Remember to test your markers in the back of your journal to make sure they don't bleed through the pages if that's not a desired effect for you.) With a black pen, fill in each box with a new and unique patterns and lettering that can be used in your doodle adventures. This is another valuable resource when you have no idea what patterns and designs to use in future projects.

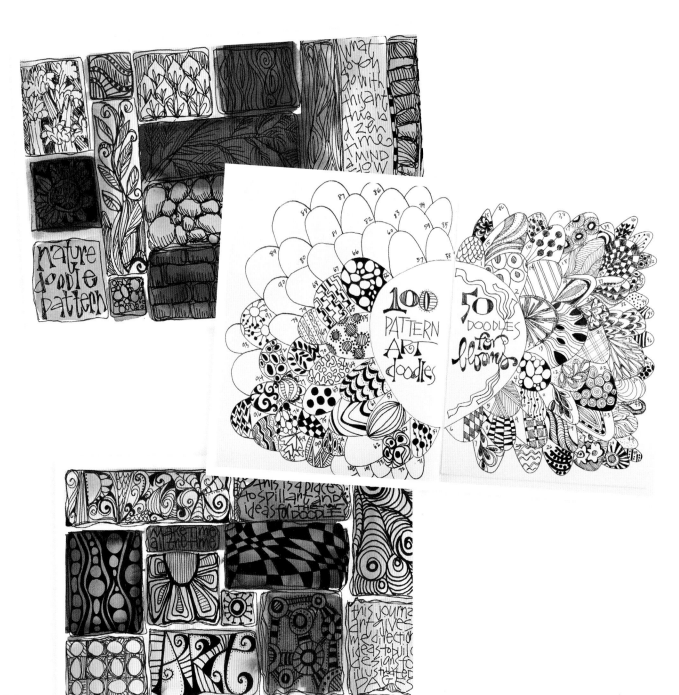

PATTERN SAMPLES

PLAYING with PATTERN

Fill a sketchbook with practice patterns and develop your own "pattern bank". Make hand drawn boxes to fill with all your drawing ideas.

...criss cross dots

...start with a swirl.

...repeating lines

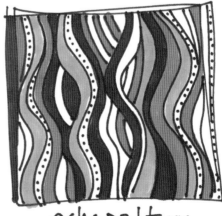

...echo pattern.

EVOLVE A DOODLE

Think of all the simple imagery that can be transformed into sophisticated doodle patterns, and design as you "evolve" the structure of an object or pattern. This is a great way to challenge your own creative thinking by simply asking "What if … " Each time your draw your chosen subject, think about what you can do to evolve the previous image by adding, coloring, changing size, and so on.

There are almost limitless ideas that will work for this process and that will completely evolve the original subject. I'm only demonstrated a few here, but as the momentum of your creative thinking builds, you are sure to come up with many more ideas. Use the descriptions and steps I have provided and then develop your own ideas. Try this process with themes and subjects like geometric shapes, things in nature (like leaves and pebbles), stars, hearts, and anything and everything you can think of. That's a lot of original doodle art derived from a simple transformation process!

Materials list
...

ART JOURNAL, SKETCHBOOK OR PAPER

BLACK PENS

MARKERS WITH THICK AND THIN TIPS

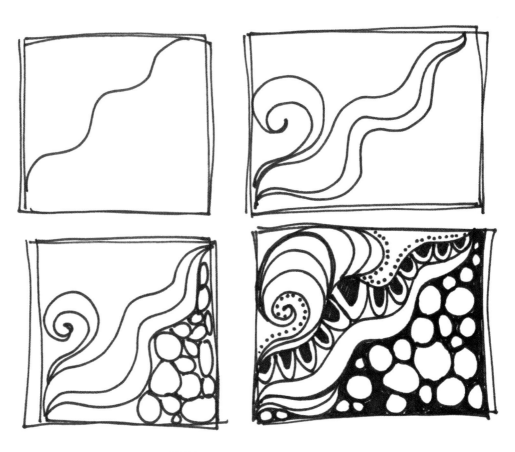

START WITH A SHAPE OR PATTERN
Create new artworks by building on the ingredients in a drawing.

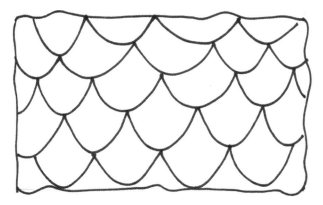

Start with a sample line or pattern, like a scallop.

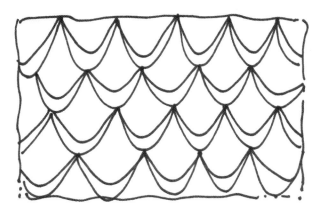

Expand and add to the line with an echo line.

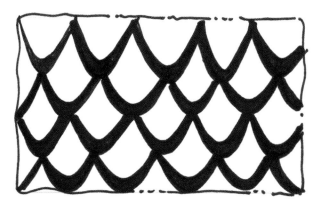

Fill in the expanded line to thicken.

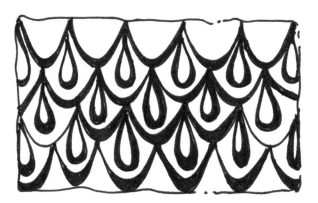

Introduce a new art element into the transformed pattern

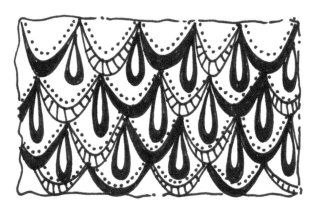

Add decorative dots to the pattern and change the scallop edges.

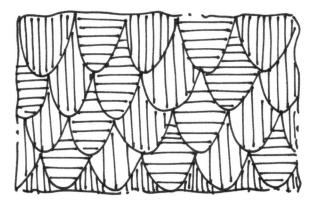

Fill in the scallop shape with alternating vertical and horizontal lines.

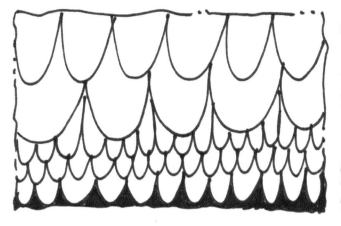

Change the size of the repeating scallop pattern as it stretches across the page

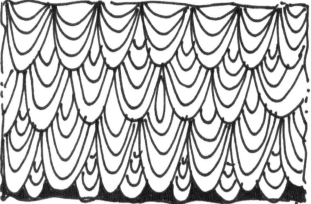

Echo the pattern inside the repeating scallop shapes.

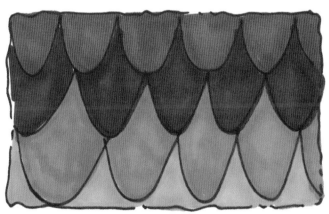

Color the pattern with markers or colored pencils.

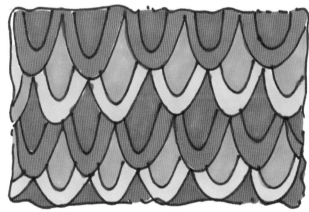

Outline the basic shapes, then color with markers or colored pencils.

EVERYDAY DOODLES

Doodle your everyday in a sketchbook or journal. Every little detail of your life is subject mtter and can be quickly and playfully documented in a quick black pen sketch and filled in with watercolor paint or marker color. Draw your words and add handwritten thoughts to the page.

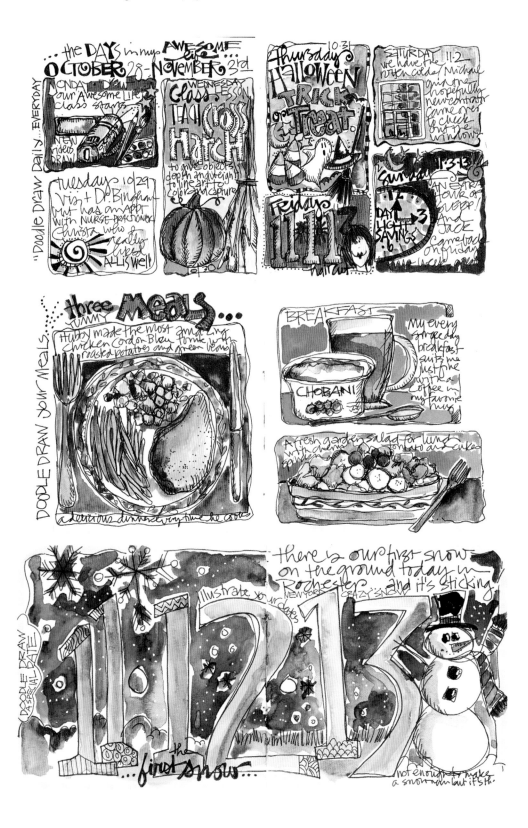

Simple or elaborate, capture the themes of the day with a loose drawing and without the fear of making something perfect. Even your to-do list and shopping lists are great subject matter with simple art and handwritten descriptive wording.

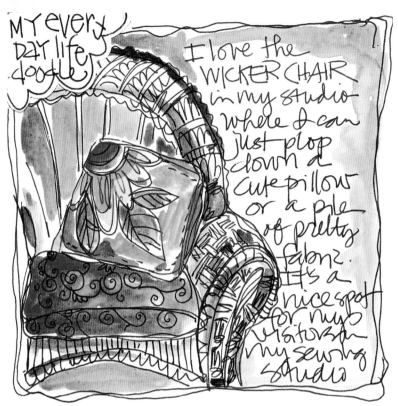

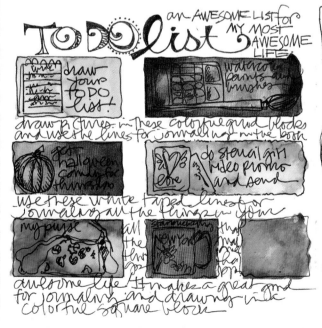

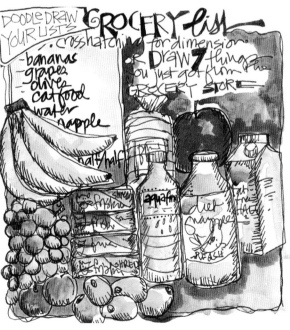

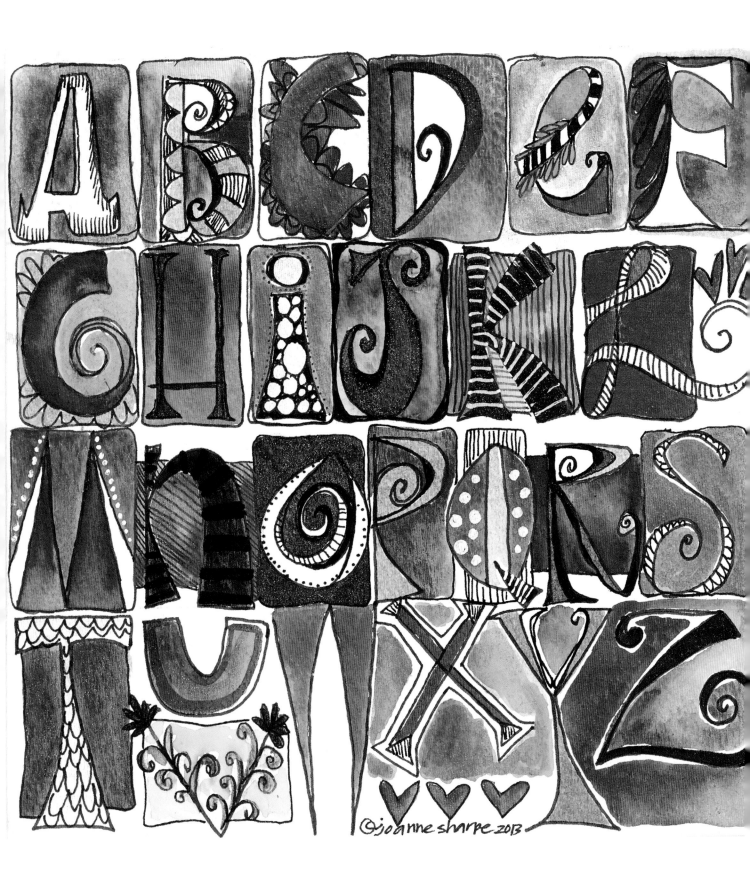

©joanne sharpe 2013

③ ALPHA DOODLES

If you can write the alphabet, you can learn to draw letters in the doodle fashion. Throughout my whole life as an artist, lettering has always been the focus of much of my work. I love language, philosophy and words that provide inspiration. My style of making art with words requires that you simply take your own personal handwriting and transform letterforms into new elements. All you really are doing is using the same process and principles used for doodling pictorial art imagery to make creative hand-drawn letters. Doodle lettering is an imperfect lettering style rooted in freehand drawing and creative expression. Anything goes, and you're only limited by your own imagination.

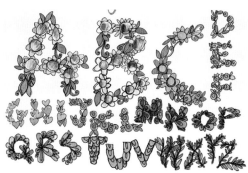
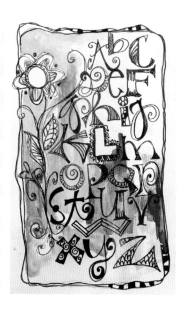

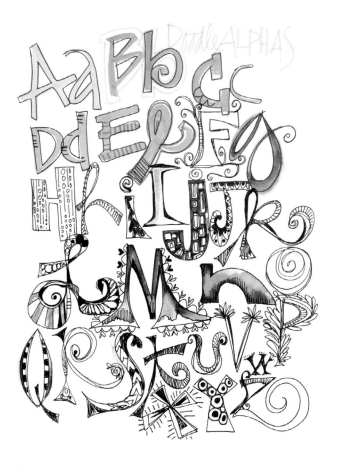

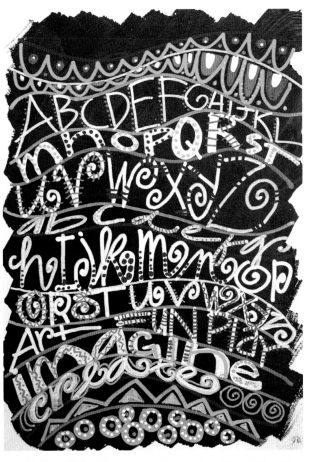

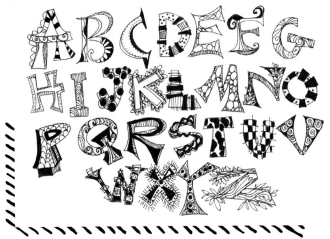

EXPLORE AND EXPERIMENT
with adding elaborate doodle shapes and patterns, transforming basic letter forms. Every little detail creates a brand new decorative letter of the alphabet.

CREATING DOODLE LETTERING

Get in the habit of doodling letters the same way you practice making patterns and pages of art. Take the shape of a letter and change the structure or move the elements to transform it. Make the ordinary extraordinary, every letter you create different from the last, stretch and exaggerate, adding parts and play.

While my lettering classes encourage the transformation of your own handwriting, I have designed several alphabets in this chapter to use as inspiration and from which you can evolve your own style and flair.

MAKE YOUR OWN LETTERS

Stretch your imagination and creativity to challenge your own handwriting. Make each letter a tiny individual work of art. Give it a theme, and name it. Use pencil sketches to define a new font in practice journals, and keep building up lettering collections that can become entire alphabets. Invent themes and try new materials to change the look of a drawn letter.

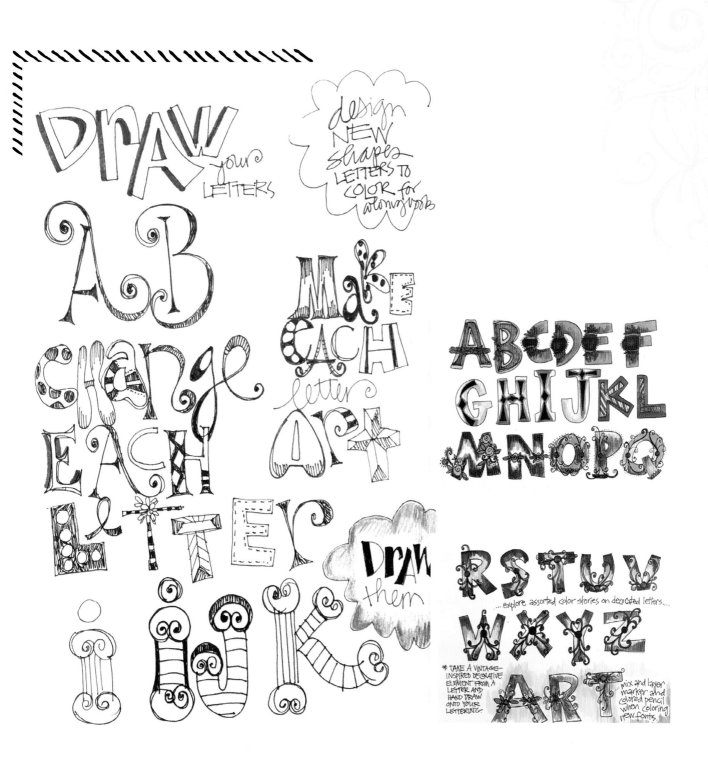

ALPHA DOODLES

Start with a very basic handwritten alphabet, add body to the letters, and then fill in the letters to create a doodled alphabet.

Materials list

..

PAPER

PENCIL

ERASER

FINE POINT BLACK PEN OR MARKER

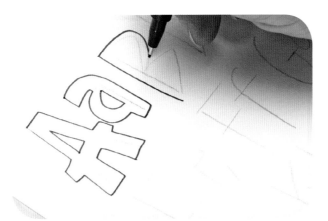

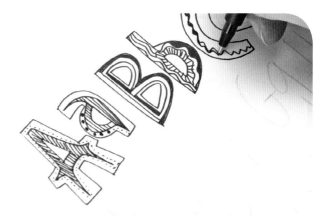

1 With a pencil, draw a basic alphabet in your own simple handwriting. Lightly trace around the entire letter with pencil again changing the look completely. Commit to the new letter design and trace around it with a black fine-line marker or pen.

2 Make decorative art patterns on the inside and outside, giving your letters a brand new identity. Try drawing the letter and echoing the outside shape inside the letter. Add exaggerated embellishments to extend the letter. This is a classic lettering doodle that completely changes a familiar form with movement and new details.

.: PENCIL FOUNDATION :.

A pencil is the first step in getting your doodle letter groove on! The most important step in drawing creative doodle letters is to always start with a simple basic letter shape using a pencil line as a guideline. The light pencil line is the "skeleton" or foundation for innovating new letterforms in the doodle style. With whatever doodle letter style you attempt, completely change the shape, add or subtract elements, and embellish with new details. When you design an alphabet, give every single letter it's own individual identity. Or choose a style and make every letter in that particular style. All of my techniques for doodle lettering use this basic premise.

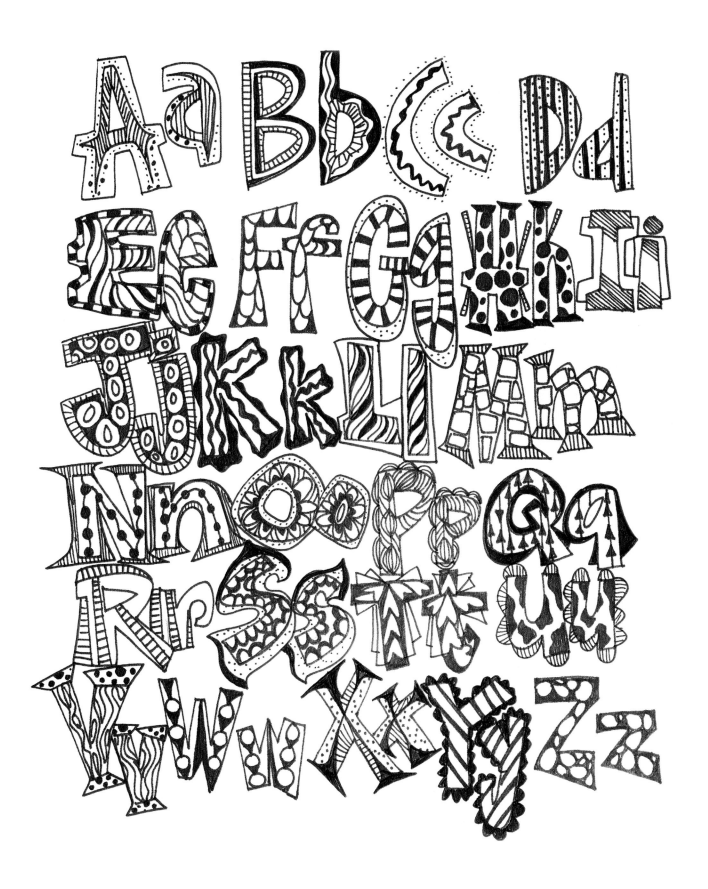

POPPING PATTERNS

This patterned alphabet is unique in its own look with letters filled with designs that pop the shape with a bold look. Change the basic letter shape by stretching the tips of the letters, making big open areas perfect for filling with pattern.

Materials list

PAPER

PENCIL

ERASER

FINE TIP BLACK PEN OR MARKER

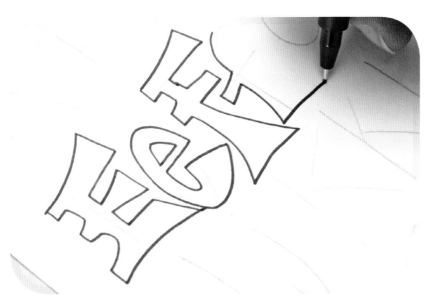

1 Start with your basic pencil shape and make a brand new letter with more emphasis on elaborating and changing the tips where serifs might appear. Outline with black pen.

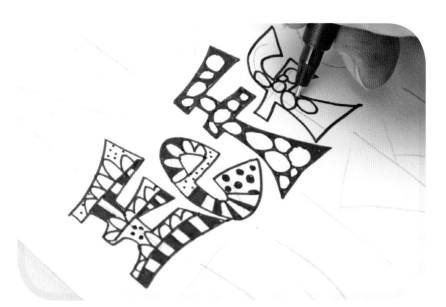

2 Fill the interior of each new letter with doodles and fill in some of the negative spaces with bold black ink so the patterns pop, giving the letters more dimension.

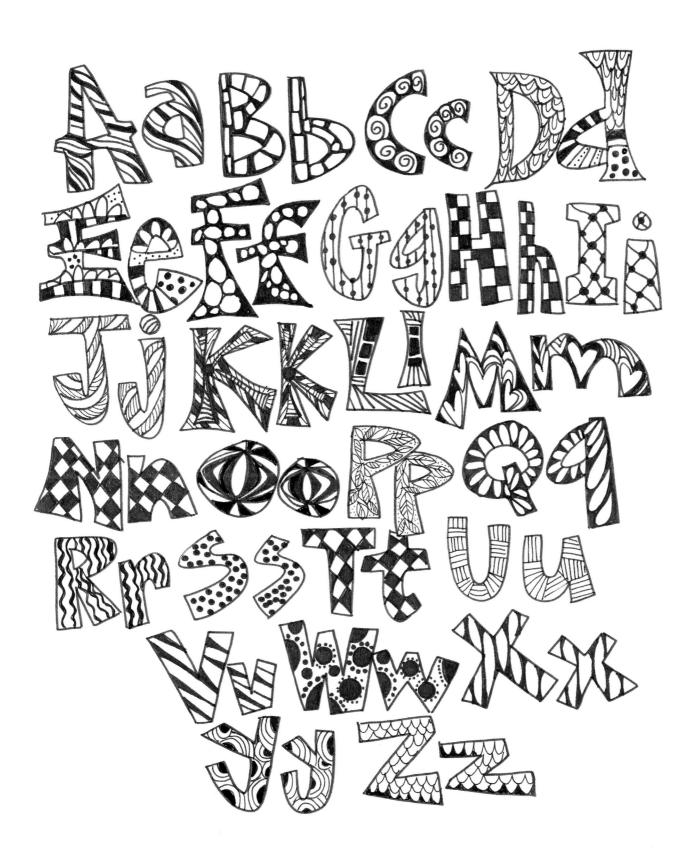

SASSY SERIFS

Why give a letter a plain flat serif when you can add pictorial art and shapes to give it a personality. Think of all the things you can attach to the ends of a letter to mimic a serif, such as petals, starbursts, swirls, flowers, blocks, and more. Thicken your letter lines to make them bold.

Materials list

...

PAPER

PENCIL

ERASER

FINE TIP BLACK PEN OR MARKER

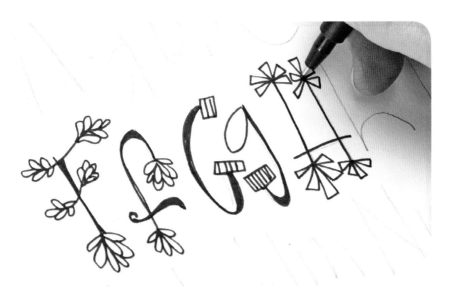

1 Pencil draw your basic letter shapes.

2 Draw over the letterform, making the lines thicker and bolder as they are traced.

3 Add creative serifs and embellishments to the ends of the letters, as shown. Make the serifs. Fill in the doodle skeletons with bold black pen.

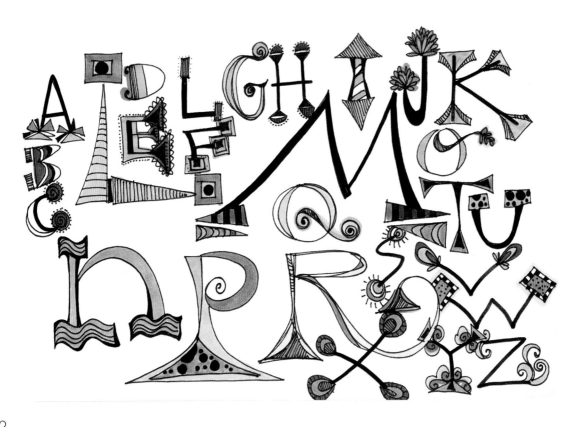

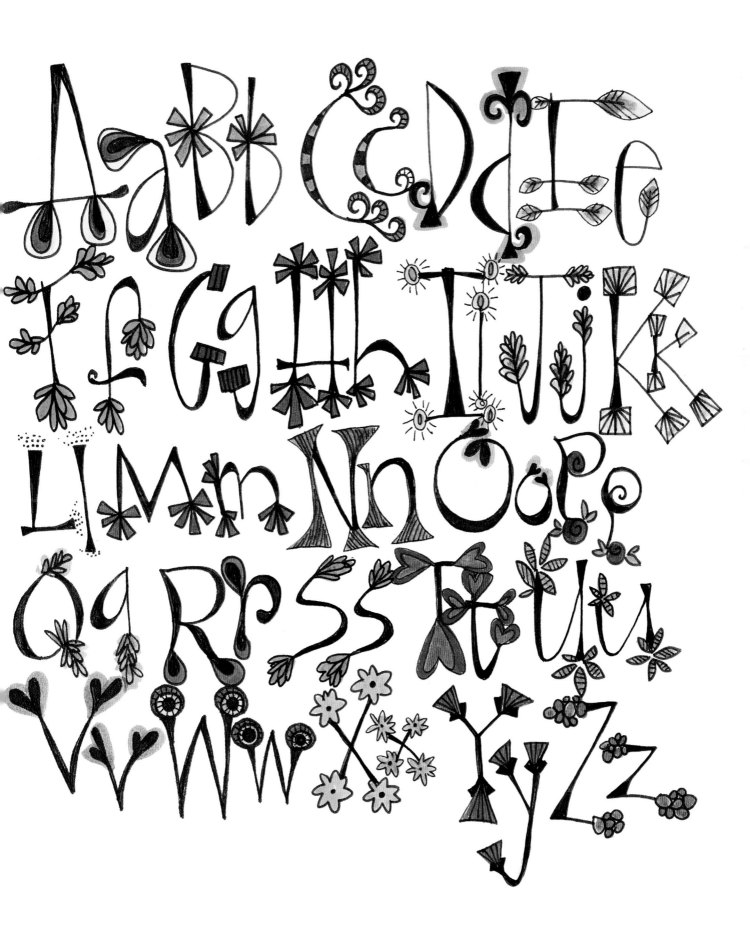

COLORING BOOK CHARACTERS

Here's a technique to make your very own coloring book style letters with doodle art. A bold, block foundation is filled in with pictorial elements and subjects to form dramatic, chunky letterforms. The trick is to doodle, draw, decorate and add color to the entire letter so it jumps off the page as a free standing illustrated art form.

Materials list

PAPER

PENCIL

ERASER

FINE TIP BLACK PEN OR MARKER

MARKERS AND/OR COLORED PENCILS

1 Make your pencil skeleton lines for the basic shape and sizing. Trace around the letter to make a bold, chunky letter shape large enough to fill with illustrations.

2 Reference the examples shown here for inspiration and fill in each letter with art butting right up against the edge of the letter shape. Trace over the doodles with a pen.

3 Completely erase all pencil lines, and reveal a letterform that is structured by the art drawn.

4 Add color to the art in the letters with markers or colored pencils, just as you would if you coloring in a coloring book.

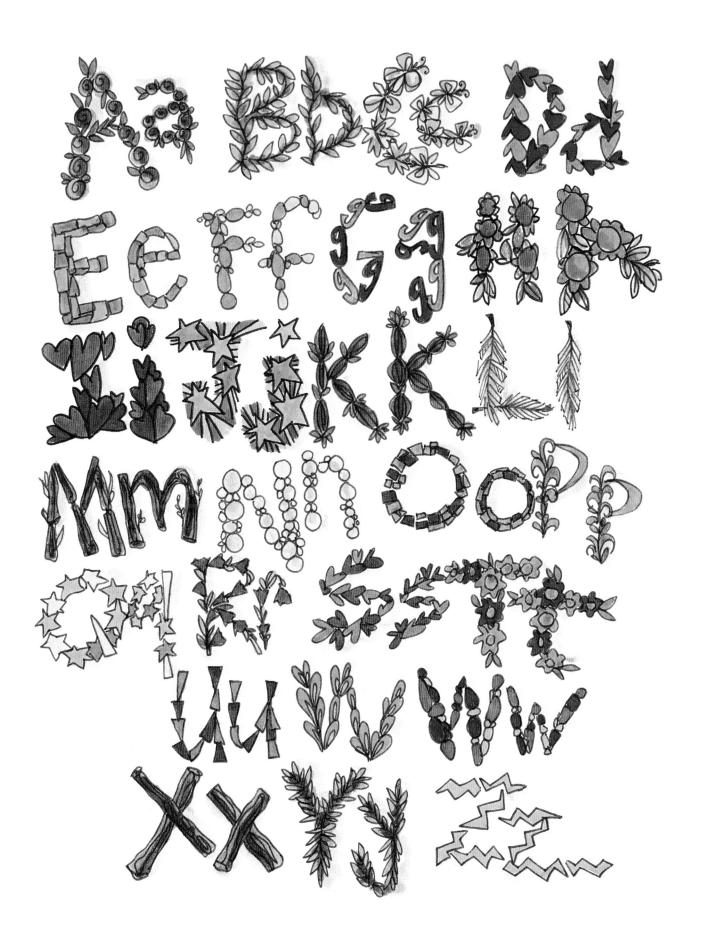

DECOR DOODLES

Decorate the line art of a letter with pattern. Use simple motifs such as circles, squares, triangles and hearts. What's special about this doodle letter idea is that creative repeating patterns are doodled on top of simple lines. The decorations and patterns can be as simple or as elaborate as you wish. Make every single letter showcase a different pattern, or design an entire alphabet with one consistent element appearing in every letter.

Materials list

. .

PAPER

PENCIL

ERASER

FINE TIP BLACK PEN OR MARKER

MARKERS AND/OR COLORED PENCILS

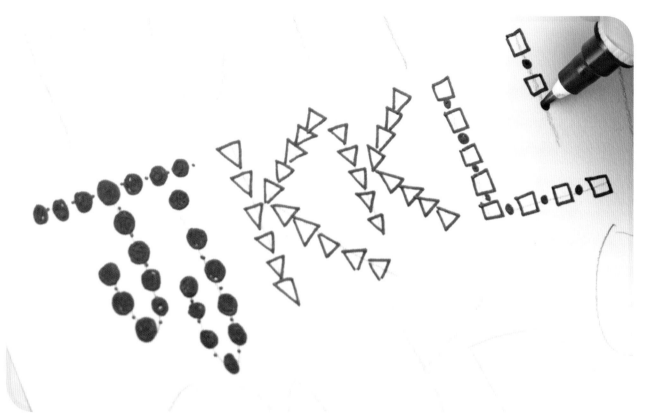

1 Pencil draw your basic letter shapes, exaggerating each letter for more interest.

2 Draw directly over the letterforms with black marker or pen, adding shapes such as dots, triangles or squares over the base form of each letter.

3 Erase all visible pencil lines.

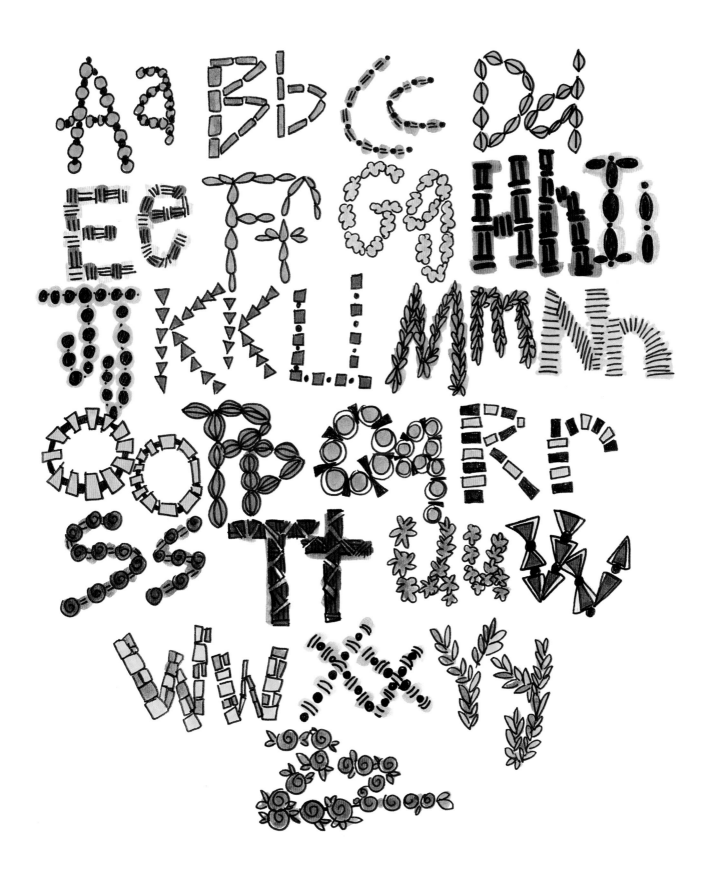

ANYTHING GOES

Make pictorial collage fonts with banners or boxes. Add art in the negative and/or positive spaces. Each letter will become a little doodle art collage element—block backgrounds embellished with doodles inspired by the marriage of imagination and basic shapes.

Materials list

PAPER

PENCIL

ERASER

FINE TIP BLACK PEN OR MARKER

MARKERS AND/OR COLORED PENCILS

1 Pencil draw basic letter shapes. Then add a background shape (such as a block or banner shape). Outline the letter shape inside the background, exaggerating as much as you want. Outline the block and banner shapes. Add doodle art in the interior negative space and around the edges of the blocks and banners. Erase any visible pencil lines.

2 Add color to your doodle drawings with markers and colored pencils. Add doodles to and color the letters if desired.

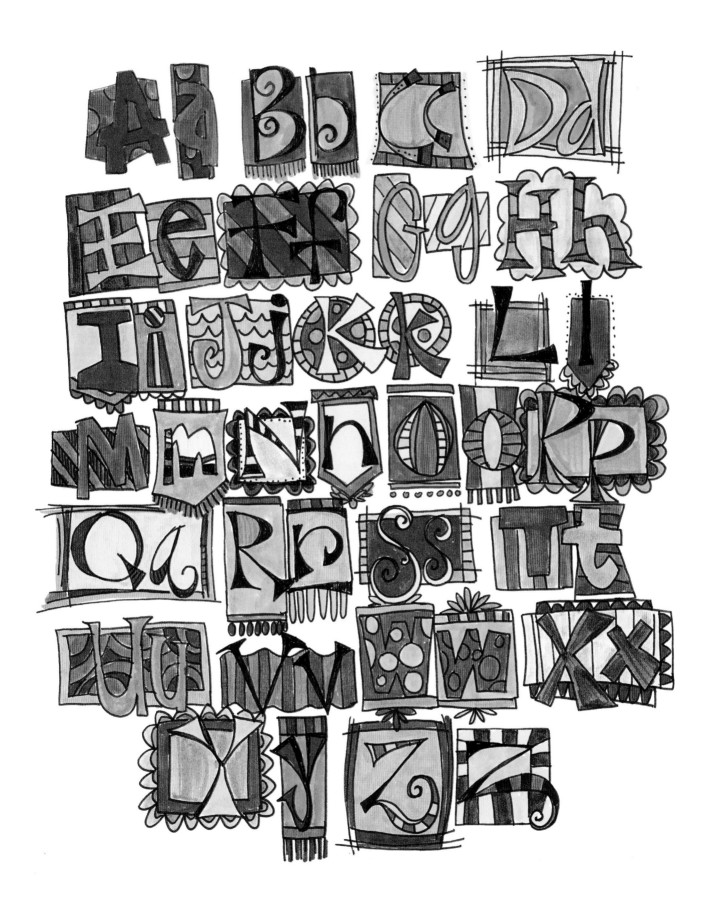

BRUSH AND SPARKLE

Doodle letters with watercolor paint and then add decorative doodles with sparkle pens to let the letters shine. The brushstrokes create large spaces in which to doodle.

Materials list

WATERBRUSH	WHITE GEL PEN
WATERCOLOR SET	PENCIL
WATER CONTAINER	WATERCOLOR PAPER
SPRAY BOTTLE	
SPARKLY OR METALLIC GEL PENS	

1 Pencil draw your basic letter shapes. Soften with an eraser if your lines are too hard or heavy. You will want to do this now rather than try to erase your pencil lines after you paint over the letterforms.

2 Using a waterbrush and watercolor paints, paint each letter using alternating pressure on the brush tip to vary the thickness of your lines and add variety to your letters. Let the paint dry completely.

3 Add colorful doodle patterns and marks to the watercolor letters with metallic or sparkle pens or white gel pens.

Aa Bb Cc Dd
Ee Ff Gg Hh Ii
Jj Kk Ll Mm
Nn Oo Pp Qq
Rr Ss Tt Uu
Vv Ww Xx
Yy Zz

LETTER LINERS

Enhance and elaborate a letterform by drawing multiple lines to define its shape. I like to call this technique "line over line over line over line" because of the repetitive, meditative pen strokes used to draw the letters. I like making little compartments for doodle art that become the structure of a letter.

Materials list

..

PAPER

PENCIL

FINE TIP BLACK PEN OR MARKER

MARKERS AND/OR COLORED PENCILS

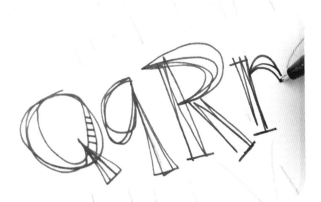

1 Pencil draw your basic letter shapes. Draw around the shape and transform letter shapes, creating openings that will become compartments.

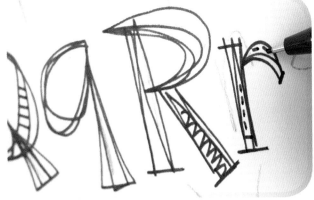

2 Fill in each compartment with elaborate, playful patterns and doodle designs like stripes, dots, checkerboards and scallops. Keep in mind that "you can't overdo a doodle!"

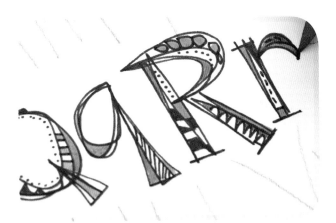

3 Color in doodles with markers and colored pencils if desired.

.: THE LINE OVER LINE PROCESS :.

Give character to the letters created with this technique with my "line over line over line over line" process. Practice on scrap paper first to get the right movements and motions for making the letters. Draw the letter correctly without lifting your pen off the paper. Next, with your pen still on the paper at the last stroke, draw the letter backward, and then forward again. You will have three sets of lines forming the letterform and several nooks and crannies in which to draw doodle patterns. Don't worry about making the letter perfect, but widen the strokes somewhat to make deeper, more open spaces.

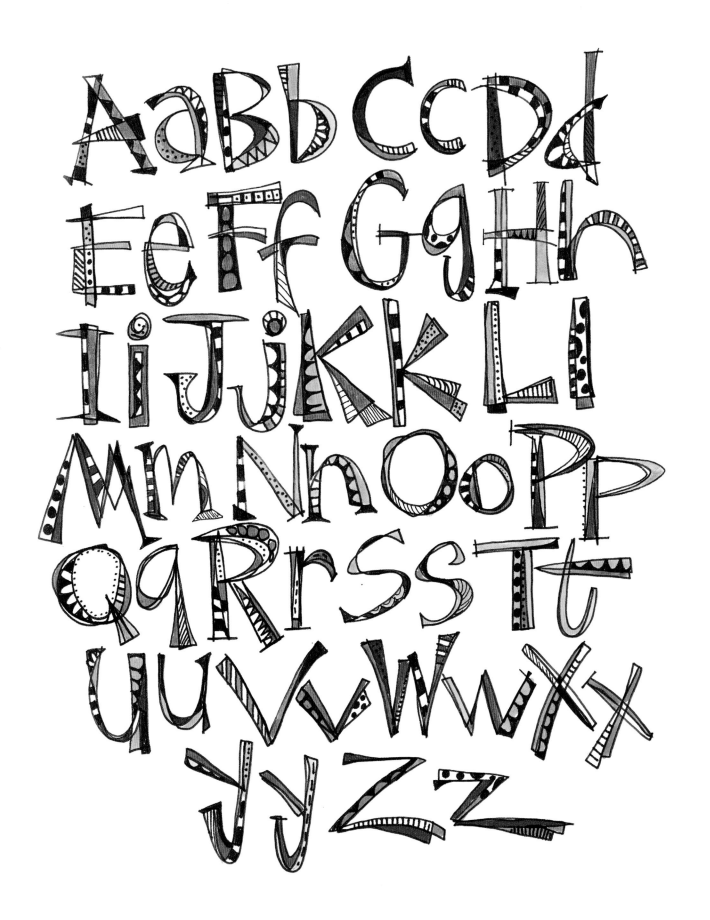

COLOR INSIDE THE LINES

This is a variation on the Letter Liners alphabet. Use the "line over line" drawing process, but rather than filling in the compartments with elaborate pattern, fill in the details with planned color stories. Try this alphabet with marker, colored pencil, or even acrylic paint as the filler. Make these letters fatter or bolder with larger spaces in which to add color. Illustrate an inspirational quote, phrase or words with this technique; it's a simple way to make a bold statement.

Materials list

PAPER

PENCIL

BLACK PEN OR MARKER

MARKERS OR COLORED PENCILS

ERASER

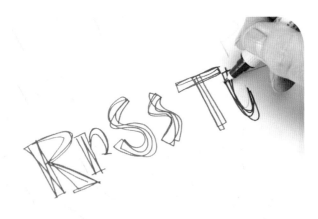

1 Pencil draw your basic letter shapes. Outline each letter three or four times with a pen without lifting that pen from the paper. Erase pencil marks.

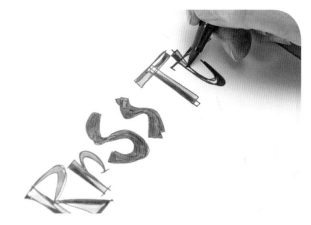

2 Fill spaces with color.

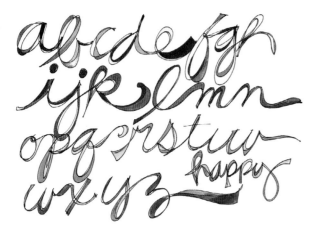

.: WHAT'S A COLOR STORY? :.

Rather than use every color in your paintbox, choose a few colors that will capture and represent a mood or setting, telling that "story." For example, if you are trying to capture the beauty of an incredible sunset in your journal, only use colors like hot yellows, reds and oranges. Are you trying to remember what it felt like at the ocean without painting the ocean? Use several shades of blue as you swirl patterns on your page.

Aa Bb Cc Dd
Ee Ff Gg Hh
Ii Jj Kk Ll
Mm Nn Oo Pp
Qq Rr Ss Tt
Uu Vv Ww
Xx Yy Zz

CURLY SWIRLS

The serif of a letter becomes the doodle element.

Materials list
...

PAPER

PENCIL

BLACK PEN OR MARKER

ERASER

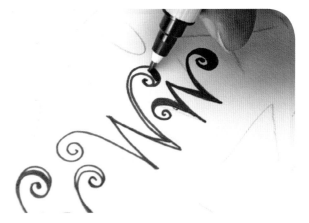

1 Pencil draw your basic letter shapes. Thicken the serif shape at the end of each letter with a circular swirling motion.

2 Exaggerate the swirl, adding weight.

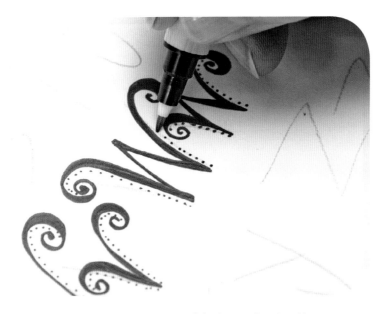

3 Add decorative dot to the linear parts of the letters for visual interest. Erase pencil marks.

Aa Bb Cc Dd
Ee Ff Gg Hh
Ii Jj Kk Ll Mm
Nn Oo Pp Qq
Rr Ss Tt Uu
Vv Ww Xx
Yy Zz

HODGE PODGE HEARTS

Doodle a heart shape at the end of a letter stroke to create a pictorial serif.

Materials list

..

PAPER

PENCIL

BLACK PEN OR MARKER

ERASER

COLORED PENCILS OR MARKERS

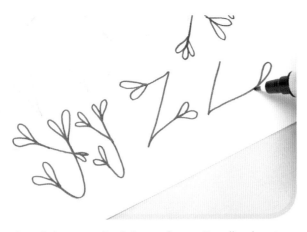

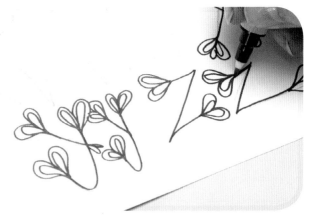

1 Pencil draw your basic letter shapes. Doodle a heart shape at the end of each letter stroke so that it becomes a part of the letter shape and is not just a heart drawn on the tip of a letter.

2 Echo the heart shapes by adding additional heart shapes.

3 Fill in the heart shapes with colored pencils or markers.

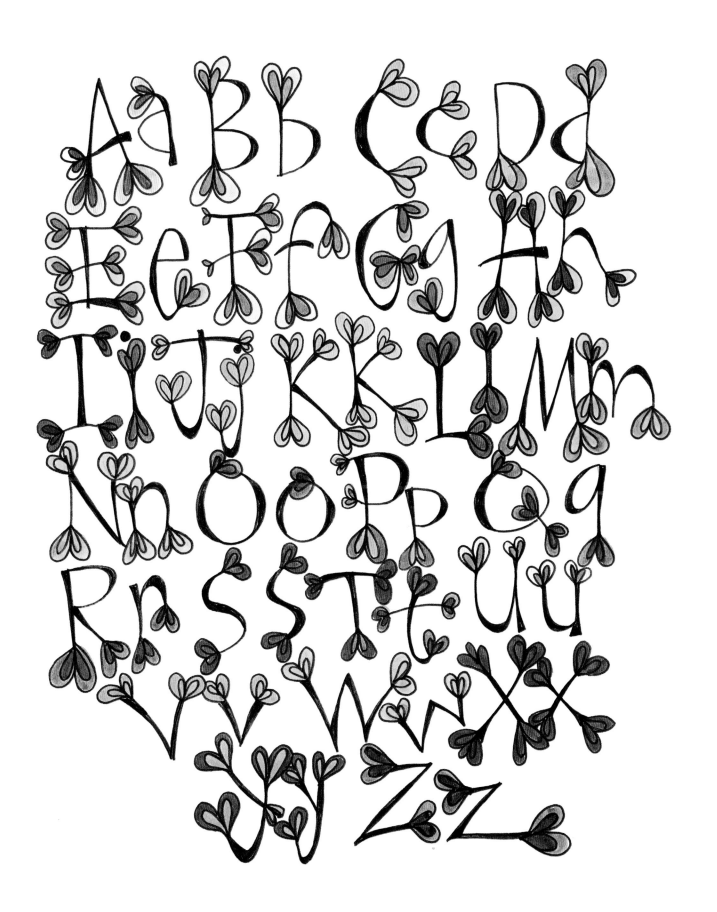

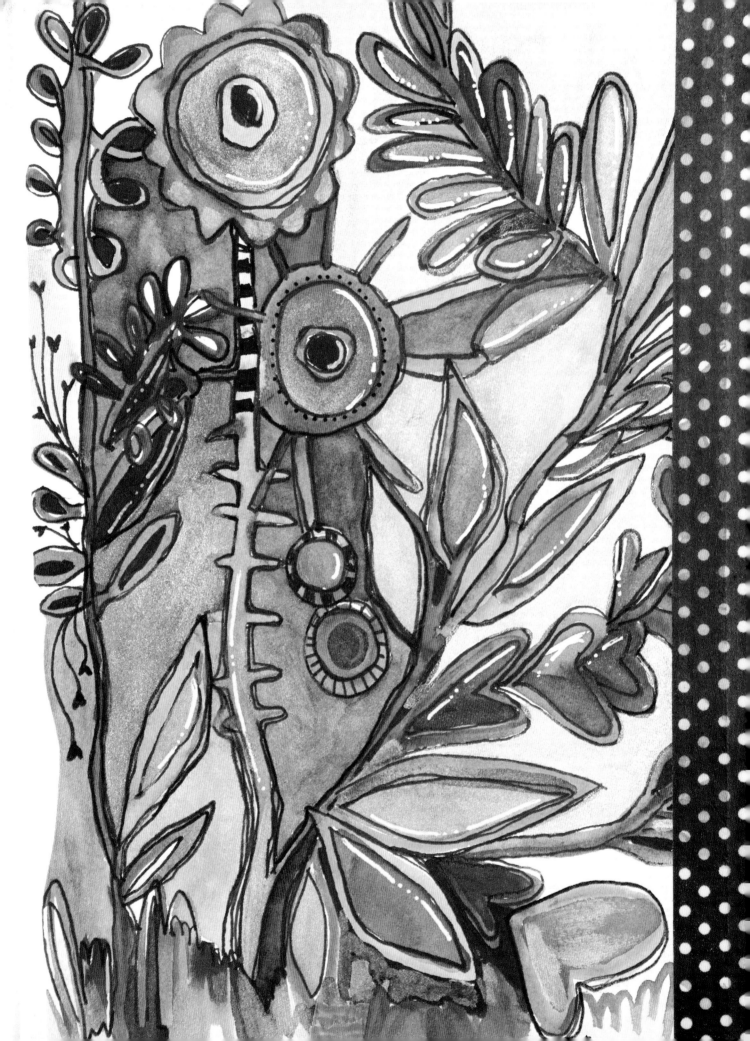

4 Technicolor Doodles

It's no secret that I really love color. Everything I create is pretty much on color overload, so this chapter is appropriately named Technicolor Doodles. On a tropical vacation years ago I packed some travel watercolors and a sketchbook. As I set up to paint in this blissful place, I panicked at the thought of giving justice to this paradise in my messy little sketchbook. Even though the art was just for me, I wanted the pages to best represent the feeling of those moments with the art created in that setting. How could I possibly and perfectly capture the lush green palm trees, the turquoise ocean and the warmth of the sand? Instead of painting a photographic rendition of this beach vacation, I decided to use my expressive freeform painting techniques to take me back to that experience. That is the day my technicolor doodle journals were born!

Embrace the idea that your journals don't have to be filled with literal images, that you can doodle draw with a paintbrush and use color, form and pattern to create an emotional connection and memory recall to an event or experience. Being in the moment with your art materials and making images on paper serve the purpose of bringing an event back to life. Get your doodle art journal ready to capture your life and memories with color. My painted doodle book is one of my favorite places to be.

WATERCOLOR PAINTED DOODLES

This idea can be used for travel journals, daily meditation and reflection, or just to practice simple art-making. Make painted doodles on single sheets of watercolor paper or in special watercolor paper sketchbooks. Use the same techniques as you would while drawing with a pen, but now make those same marks with a loaded waterbrush or paintbrush.

Materials list

WATERCOLOR PAINTS

WATERBRUSH

WATERCOLOR PAPER

PENCILS, PENS, GEL PENS
FOR EMBELLISHING

1 Choose a color story and use a waterbrush and paint and create patterns. Make free-flowing, organic shapes and let dry.

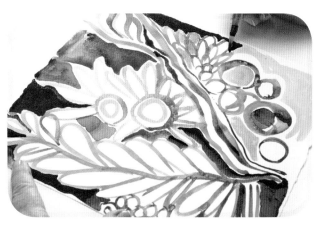

2 Fill in the negative spaces with color.

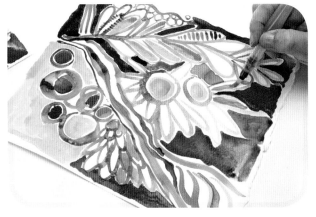

3 Add decorative elements over the lines and in the shapes created.

.: WHAT'S A COLOR STORY? :.

Rather than use every color in your paintbox, choose a few colors that will capture and represent a mood or setting, telling that "story." For example, if you are trying to capture the beauty of an incredible sunset in your journal, only use colors like hot yellows, reds and oranges. Are you trying to remember what it felt like at the ocean without painting the ocean? Use several shades of blue as you swirl patterns on your page.

CAPTURING MOMENTS, NATURE, EMBRACING ABSTRACT

Some of my most favorite artworks are right here in the pages of my Painted Doodle Book. Most of these images take me back to a time and place I visited while traveling and some are just random sittings with my paints and journal. These are my go to pages when I want my art to capture a memory or just paint in thought.

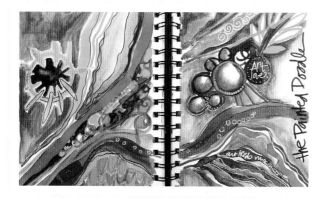

A simple page to play with bold, bright color sweeping across a two-page spread, painting just to paint. I also experimented with some watercolor pencil, gel pens and paint markers.

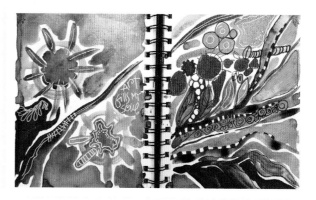

So many paints, so little time! I continue the same process of painting across two pages using similar themes, but here I use sparkly, metallic watercolor paints. These pages capture light and shimmer. Try the same techniques with different types of paint.

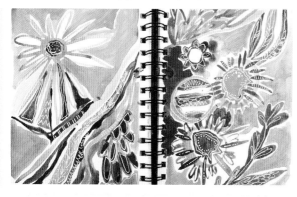

This is an example of a tropical vacation travel page. The color story uses only turquoise, coral, lime green and gold. It immediately takes me back to the day and the place I painted this. White gel pen work adds decorative accents and pops the colors.

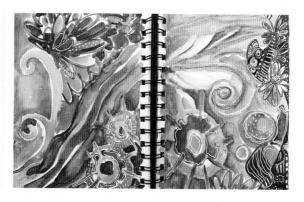

This is a class demonstration page I used to teach a group some of the basic ingredients of this technique. Start with painted undulating lines that reach across two pages, spiky concentric circles, simple swirls and repeating petal patterns, and cover the page (try to paint the pages and leave no white space visible).

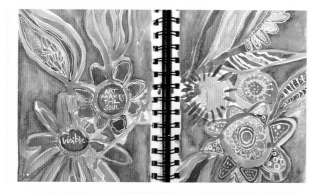

This is another travel page that captured moments in a lush, green oceanic place. Mindfully doodled white gel pen accents add interest and pop off the page.

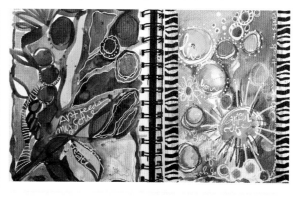

On these pages from a teaching event, I play with primary colors, circle patterns and a smooth flowing white gel pen.

DOODLE BRUSH PATTERNS

Every doodling technique using a pen can also be done the exact same way using a paintbrush and watercolors. You'll need a smaller-tipped paintbrush, like a watercolor round #2 or #4, to make clean, crisp lines, or a waterbrush to do the same. It's so liberating to draw with a brush dripping with color and that glides across a surface while your mind slowly swirls and makes every mark a perfect expression.

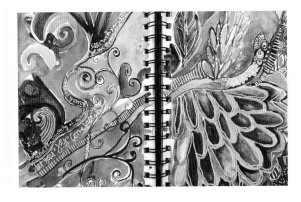

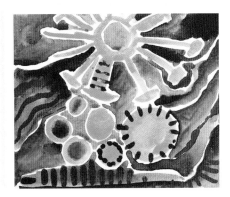

Use a two page spread to practice repeating patterns like scales and swirls. When you can't come up with ideas, look to nature to find models for pattern. For example, the bold scales on this page mimic the texture of a pine cone, which was used for my inspiration here.

Circle shapes provide a central focal point that draws the viewer into the page with a painted background. Bursts of line, extending off the circles, animate the shape and provide movement that explodes on the page.

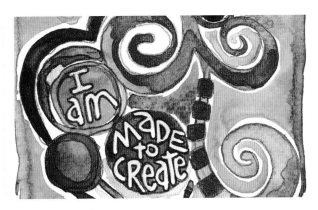

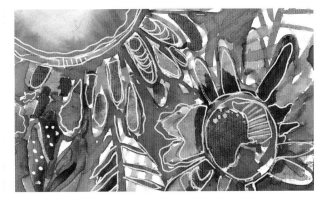

Painted shapes, repeating patterns and text filler create a canvas for doodle drawing embellishments.

The same familiar doodle lines and shapes are made with a paintbrush. Thin and thick loose lines and moving lines in various thicknesses energize the flower shape.

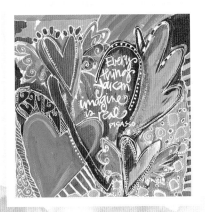

Images are painted with acrylic paint, creating a slick surface for a white gel pen to skate across the page popping the color with animated line work.

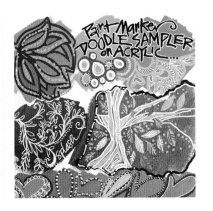

Patches of color are painted with acrylics and then decorated with an acrylic paint pen.

THE PAINTED WORD DOODLE

Once I get in the "doodle zone" making journal pages, I find that words appear in the midst of colorful leaf shapes, circles and bending lines. When filling pages with doodle art there is always room for lettering practice—illustrating language, free-flowing thoughts and inspirational quotes. Use all types of pens and markers in the tiny doodle spaces and let your art speak.

Insert a favorite quote into a doodle-art framed page; hand-letter with a waterbrush.

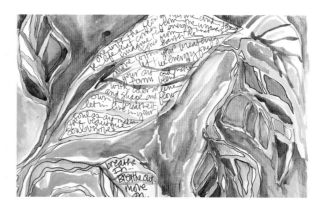

Let leafy imagery drape across a two-page spread, and fill in the leaf sections with cursive handwriting as a filler pattern.

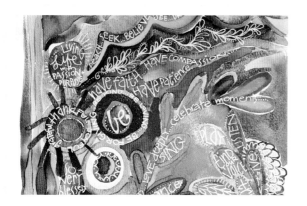

Hand-write words and personal reminders in the painted lines, sizing the lettering to fit created shapes. White gel pen pops the words off the page.

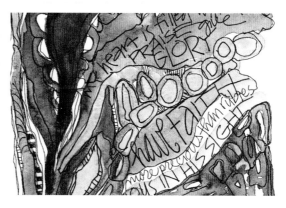

Organic lines and open spaces serve as compartments for writing thoughts with a black ink pen.

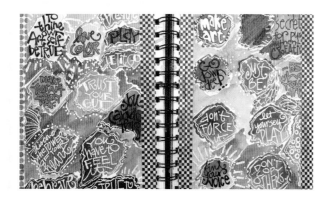

A page adorned with acrylic-painted abstract shapes: The shapes are perfect frames for lettering with a white gel pen.

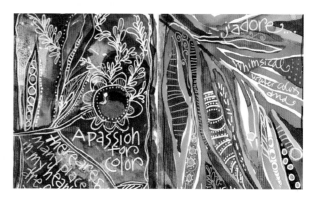

Use contrasting colored markers to letter words inside shapes, and then outline the words with a glittery gel pen.

MARKER PUDDLE DOODLES

This technique came as a happy accident when I was doodling in an art journal with alcohol-based markers, and the markers bled though the page. Doodling around the bleedthrough makes it look intentional. This is a great technique to use in a dedicated marker journal.

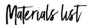

Materials list

ALCOHOL AND DYE-BASED MARKERS

BLACK PEN

PAPER (I LIKE TO DO THIS TECHNIQUE IN MY MOLESKINE SKETCHBOOK.)

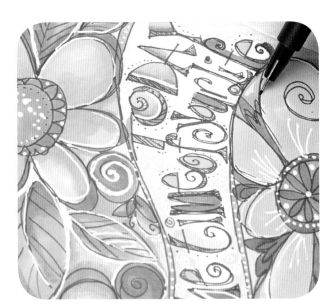

1 Make a whimsical colorful marker drawing on some "thirsty" paper.

.: FIND THE RIGHT PAPER FOR YOU :.

Test and experiment with various types of paper that absorb marker ink and leave streaks behind (like printer paper or thick journal paper) to see what will work for you and what effect you like best. For example, I like the way the pages of my Moleskine journal absorb the ink and I often do this technique in that journal.

.: BEWARE UNWANTED BLEEDTHROUGH :.

It's a good thing when that unsightly marker color bleeds! This technique is rooted in the fact that alcohol-based markers (like Copic, Prismacolor and Sharpie) bleed through paper. When making Marker Puddle Doodle Art you'll color a heavy design on the front of a page. If working in a journal, tuck a separate sheet of paper behind the drawing page to protect the page that follows.

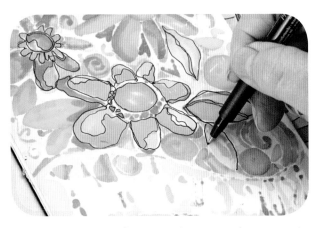

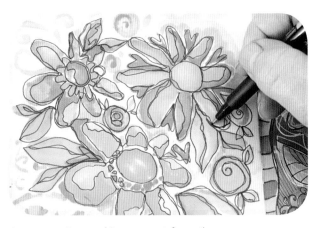

2 Flip or turn the page and create an abstract interpretation, making new art from the ink that bled through. With a black fine-line pigment-ink pen, outline each puddle individually, tracing the organic and juicy shapes to make new imagery.

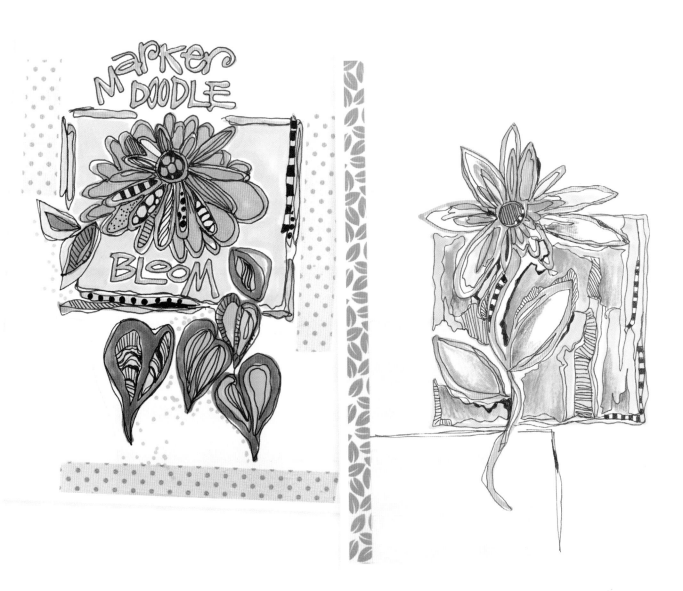

.: USE CAUTION WHEN MIXING MARKER INKS :.

In the marker puddle technique, a pigment-ink marker is suggested for outlining the color patches. Know that the chemistry of pigment, dye-based, alcohol and solvent marker pens are all different. Alcohol and solvent markers don't always play nice when mixed on a page and may smear when used together. A pigment marker will not react to alcohol or solvent-base pens. It's best to try marker pens together on a separate piece of paper before you start a project to make sure you are not going to have any undesirable surprises like smearing and muddied color.

PAINTED DOODLE SAMPLER BOOK

Sometimes you just need a tiny little place to doodle. You crave the time and place to create but you don't feel like dragging out all your supplies. Or maybe you want to try some new paints, or you're short for time. A handmade accordion book is the perfect place to make art. It's small, portable, not overwhelming and you still get the credit for art making.

Materials list

WATERCOLOR PAINTS

WATERBRUSH

LARGE PIECE OF WATERCOLOR PAPER

BLACK PEN

WHITE GEL PEN

1 All you need is one large sheet of watercolor paper—20" × 30" is a standard size—to make four individual accordion books. Cut the sheet of watercolor paper into four pieces, each measuring 5" × 30". Fold each piece in half so you have 2 pages. Fold each page in half so you have 4 pages. Fold each of the 4 pages in half so you have 8 pages. Refold along each fold so the pages are folded as shown in the photo.

2 Use a brush to draw with watercolor paint. Start by making loose painted lines, alternating the pressure on the tip of brush to make bumpy lines. Keeping the paper in landscape format, you can choose to paint across several pages or make artworks on each page individually.

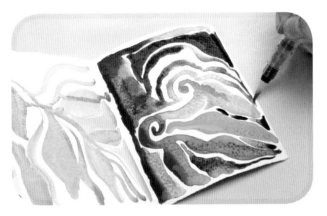

3 Continue painting until all the accordion book pages have been filled. Allow the paint to dry completely. This doesn't have to be finished on one sitting. It can be a handy tool you can have readily available to make art in when the spirit moves you.

4 Let painted pages dry completely. Embellish the colorful artworks with decorative doodles, repeating lines, dots and outlines with a white gel pen, sparkle and metallic pens. (The white gel pen is the most dramatic in this technique.) Keep adding until your heart's content, because remember that you really can't overdo a doodle!

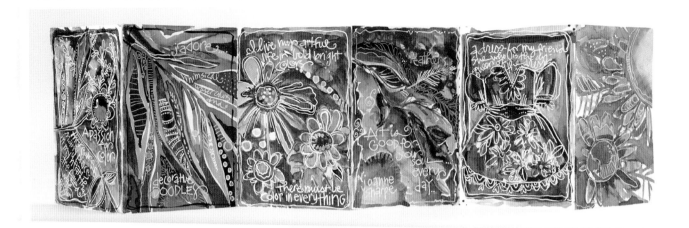

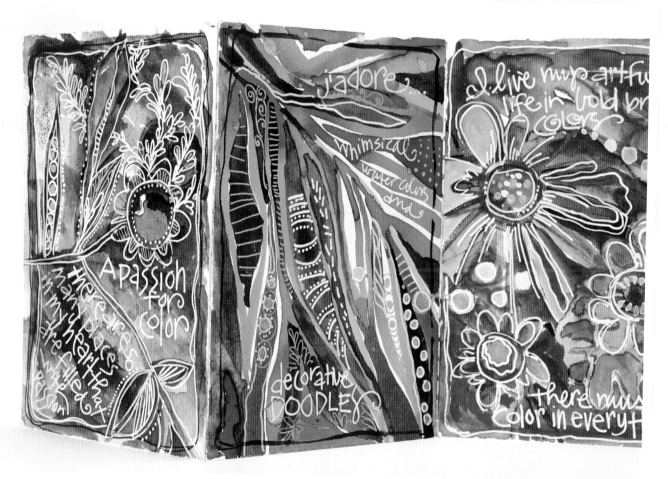

.: EMBELLISHING YOUR PAINTED DOODLE SAMPLER :.

Be sure to use a mix of light and dark paint colors for this technique; white doodles on dark paint will really pop as will black doodles on light paint. Keep adding doodles and marks over the painted shapes and lines, creating new imagery.

For added texture and interest, let your paint dry, and then add another layer of paint over the first.

MARKER MASTERPIECE

I like to make little compartments to draw in, and I like to use the shapes for background patterns—colorful marker work is the perfect setting for black line doodle work to pop off a page. These little accordion books are perfect for making little artworks on the go; just fold up the panels to make a portable drawing book. I like to think of this technique as a patchwork of doodles.

Materials list

COLORFUL MARKERS

BLACK PEN

JOURNAL PAGE OR ACCORDION BOOK
MADE FROM WATERCOLOR PAPER

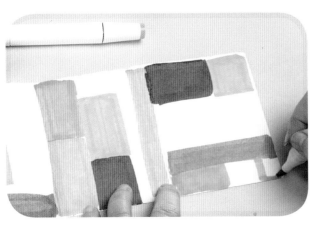

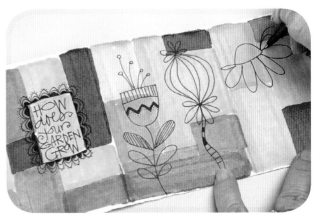

1 Use your favorite markers to loosely draw block shapes that fit into each other like tiles. Completely cover the entire paper spread with a specific color story or theme. Remember, alcohol markers will saturate the paper nicely, but be aware that they might bleed through to the other side.

2 Using a black pen, doodle your favorite imagery, patterns, designs or words onto the panels. You can even use this technique to make greeting cards or table decorations for celebrations.

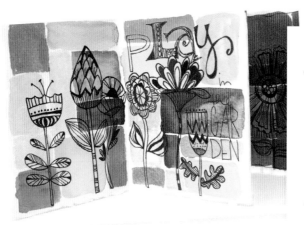

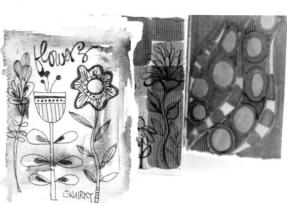

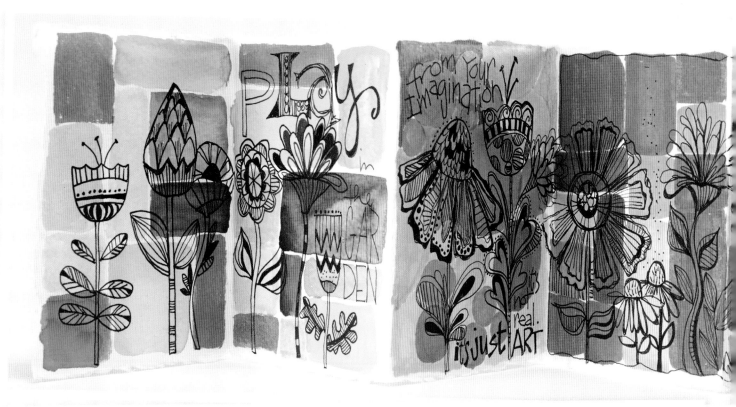

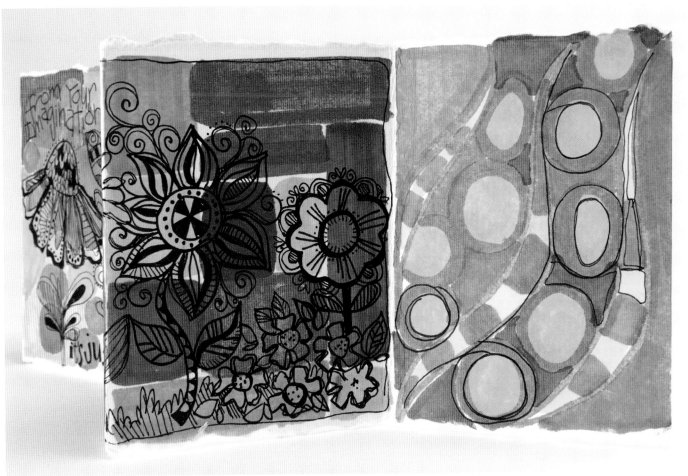

5 Pages, Frames and Borders

Doodle art is the perfect way to adorn your art and journal pages with decorative details. Frame your favorite words, quotes, messages or writing with your own motifs, patterns and designs. When making frames and border art, the key is to keep adding simple imagery with repeating patterns, embellishing until the image stands on its own commanding a playful and dramatic page presence. The art and pattern that extends all the way around the surface is what draws the viewer into the piece and then directs her to settle in on a sentiment that usually appears in the center of the frame. Borders and frames are the perfect finishing touch for message-themed journal pages, cards and wall art.

BORDER BASICS

Start the process of making an art piece or page with a decorative doodled border. To me, the looser, more freehand drawn, the better. I rarely ever use a ruler or straight edge when making my decorative art borders and frames. Working with a very light pencil outline first gives me enough guidelines and direction to commit to the design in pen and marker. This truly is the art of "perfectly imperfect perfection." This is my art style, my own personal expression, and how I choose to make art. If you are a ruler person, by all means, start with a light pencil outline using a straight edge. It's OK! Being a real free-spirit doodler might take a little time. But once you give yourself permission to just play and go with the art that flows from you, your pens will be dancing all over the paper.

Materials list
...

PAPER

BLACK PENS

PENCIL

ERASER

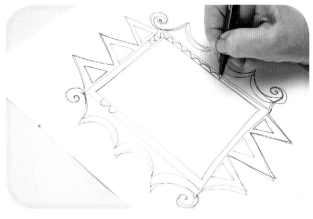

1 In pencil, lightly and loosely draw a vertical rectangle and some shaped framed edges filling the page space.

2 With a black pen, commit to the formation and begin to add organic and geometric shapes around the frame. Keep adding, building and repeating the details until the border is full.

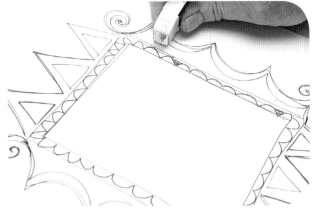

3 Embellish the insides of the open shapes with your favorite pictorial elements like leaves, flowers, hearts, polka dots, stripes and geometric shapes.

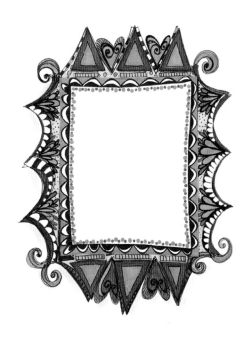

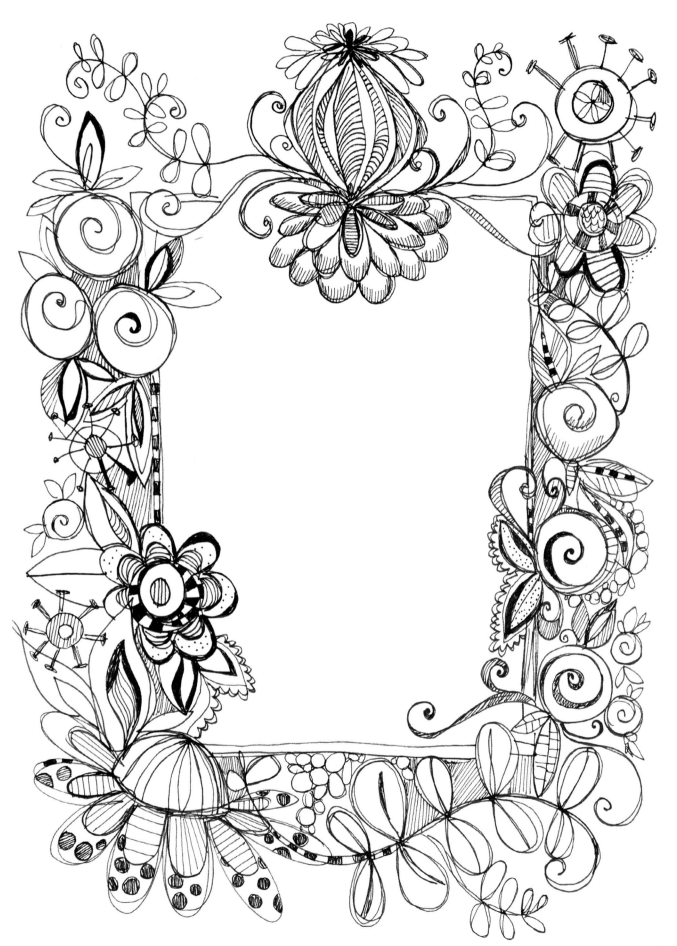

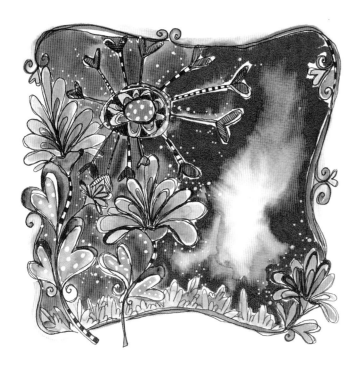

CARDMAKING BORDERS

Perhaps you have never considered making your own greeting cards. "Doing the doodle" and getting comfortable with whimsical lettering art gives you the tools and confidence to go ahead and make art with a purpose. Combine the principles of loose drawing, colorful appealing imagery and hand-lettering to make custom and personal greetings. Use heavy cardstock or watercolor paper to create card borders and color with markers or watercolor paints. Leave a significant space open in the design layout for adding words and greetings. Make colored photocopies or scan the background art into your computer and print each time you need to give a card.

FRAME IT FOR INSPIRATIONAL QUOTES

Take your art out of the journal and create beautiful works of inspirational wall art. Your doodle drawing can become a built-in frame and will add pop to a quote or phrase. In addition to making swirls and curls to form a border, add hand-lettered words in the edges as well. Play with the composition, arranging the art elements in various positions on the paper, like placing imagery on the left side or stretching art across the entire top and bottom. The art can be as simple as a black line drawing or as complex as a full-color patterned fill of the open space in your piece. Style with your message with hand-lettering inspired by some of the alphabet styles in this book.

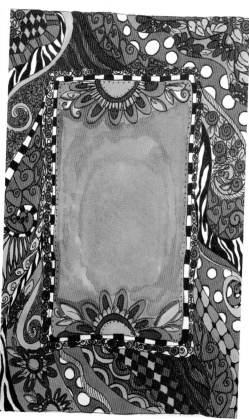

JOURNALING BORDERS IN AN ART JOURNAL

In my creative practice, the purpose of an art journal or sketchbook is to have an easily accessible, convenient place to draw, doodle, paint and write every single day. A page never looks complete to me until it is some how bordered with pen or paint. I have piles of journals and cherish them as personal chronicles of my life's journey, using art to think, play, reflect and practice. It's very fulfilling to look back. There are times, though, when I just need to make art. And during those times, I embrace the first clean white page I come to. I begin by making a border, drawing just to draw or painting just to paint. The decorated page art may come with another purpose at another time when I am moved by impulse to add words or writing. Spontaneous page preparation and art making satisfies my innate need to create every day. It is the most satisfying process just to be creative. Sometimes I make border art in my journals just to experiment with art supplies or techniques. Such framed pages and lively, playful artworks wait for the opportunity to feed my soul.

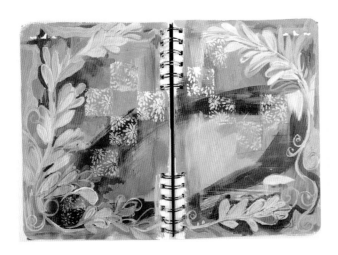

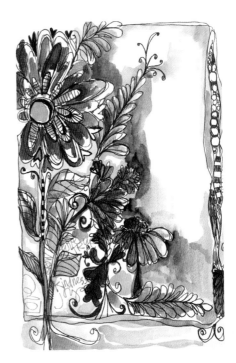

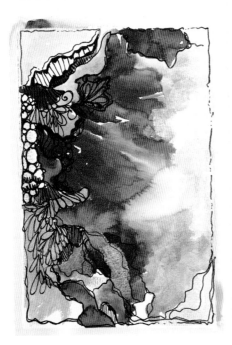

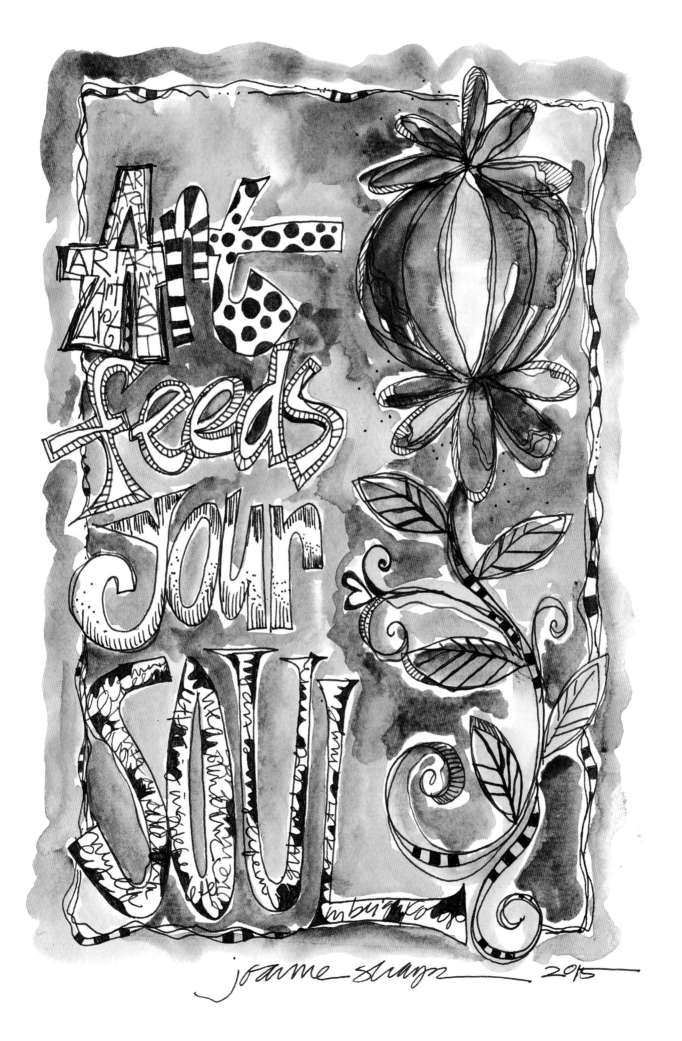

Art feeds your soul

joanne sharp 2015

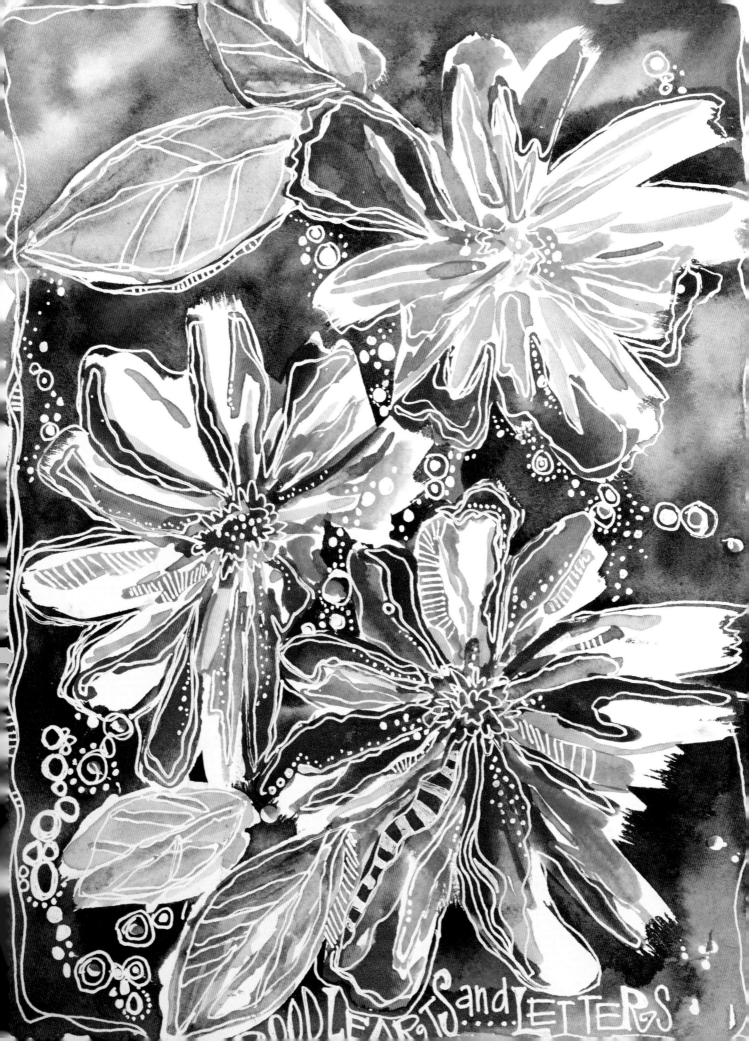

DOODLEARTSandLETTERS

6 Artful Doodle Do's

Make art all the time, see art everywhere. Keep a pen or marker ready to meet paper when inspiration strikes. There should be a special place for creating, exploring and inventing your doodle art, and an art journal or sketchbook is that great go-to tool to keep the ideas flowing. Get in the habit of making doodles each day, every day taking a pattern or image one step further. Challenge yourself to be constantly looking for how you will interpret your ideas and surroundings. Stretch your art muscles. Always draw one more line, one more pattern, and watch your doodle art bank grow, grow and grow some more.

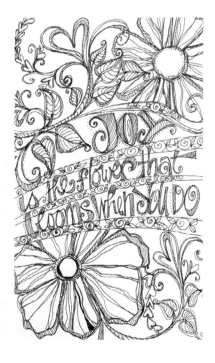
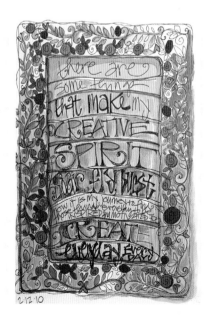

100 DOODLE DO BOOK

Create your own reference book of personal drawings to inspire all your doodle art. Challenge yourself to start with 100 small cards with themes and ideas generated from observations of everyday life.

Materials list
...

SMALL CUT PAPER OR INDEX CARDS

HOLEPUNCH

BLACK PENS

BINDER RING

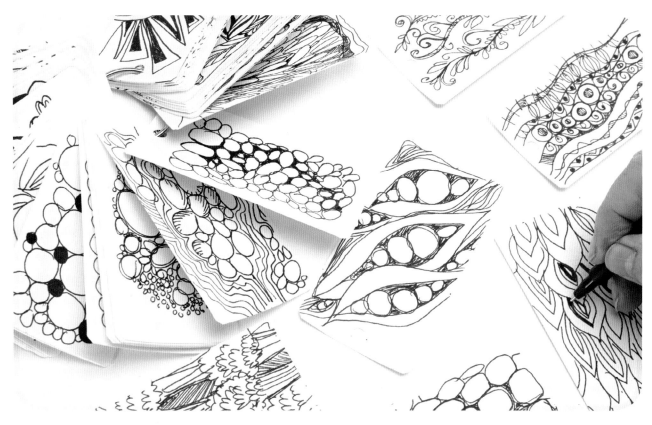

1 Assemble a small book approximately 3" × 4" with 100 cards (or use standard sized blank index cards). Punch a hole in each card, and slip the pages onto to a large binder ring.

2 Make a list of 25 inspirational themes and ideas for imagery. For example, some items on my list are tree bark, flowers, fruit, pebbles, leaves and insects.

3 One hundred little drawings might seem daunting, but draw four different versions of each item on your list, evolving and changing the item with each doodle. You'll be surprised at how quickly the task is complete and you'll have a stack of new ideas on a ring.

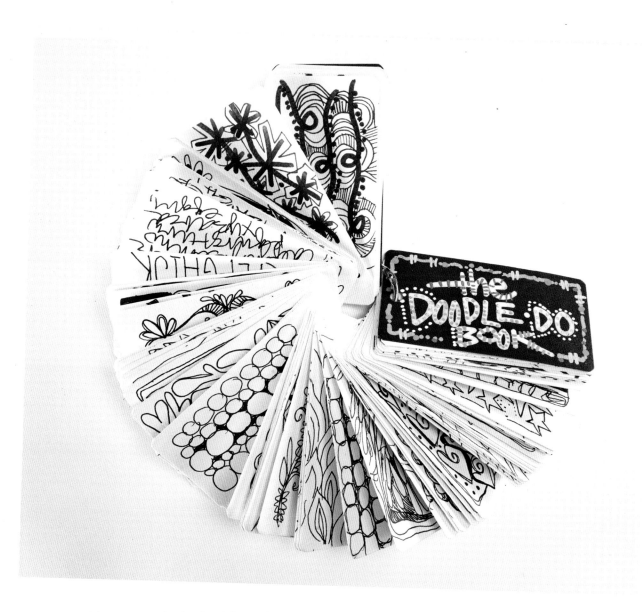

It's no mystery that is takes daily, consistent practice and concentration to master, well, anything. In creating doodle art, you have to challenge your thoughts and anticipate what will come next in the process: What can you add to an existing image? How can you change the look? Elaborate and change an image with one more pen stroke. Add pattern ... The Doodle Do book is an essential reference and resource in developing creative ideas.

.: DON'T LOOK. SEE. :.

Don't just look at your surroundings. See how everything can become a doodle or drawing with potential for line, shape and pattern. When teaching this concept, I tell my students, "It doesn't matter how you look, it's how you see." Everything you see should inspire a creative response. Supercharge your thoughts to find all the possibilities in the details of everything.

PATTERN JOURNAL

Ordinary, familiar objects are excellent inspiration for discovering design elements and inventing pattern. The following pages from my journal are examples of small cards I made to elaborate the shapes I see in the food that comes from nature. Fruits and vegetables have amazing characteristics that can become really interesting and unique art elements.

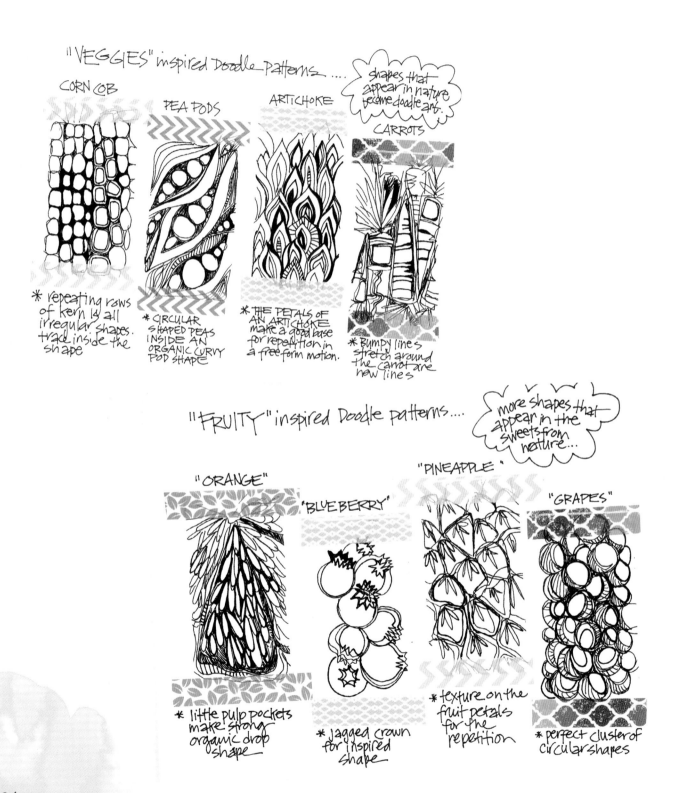

"VEGGIES" inspired Doodle Patterns

shapes that appear in nature become doodle art.

CORN COB

PEA PODS

ARTICHOKE

CARROTS

* repeating rows of kern & all irregular shapes. trace inside the shape

* CIRCULAR SHAPED PEAS INSIDE AN ORGANIC CURVY POD SHAPE

* THE PETALS OF AN ARTICHOKE make a good base for repetition in a free form motion.

* Bumpy lines stretch around the carrot are new lines

"FRUITY" inspired Doodle Patterns

more shapes that appear in the sweets from nature...

"ORANGE"

"BLUEBERRY"

"PINEAPPLE"

"GRAPES"

* little pulp pockets make strong organic drop shape

* jagged crown for inspired shape

* texture on the fruit petals for the repetition

* perfect cluster of circular shapes

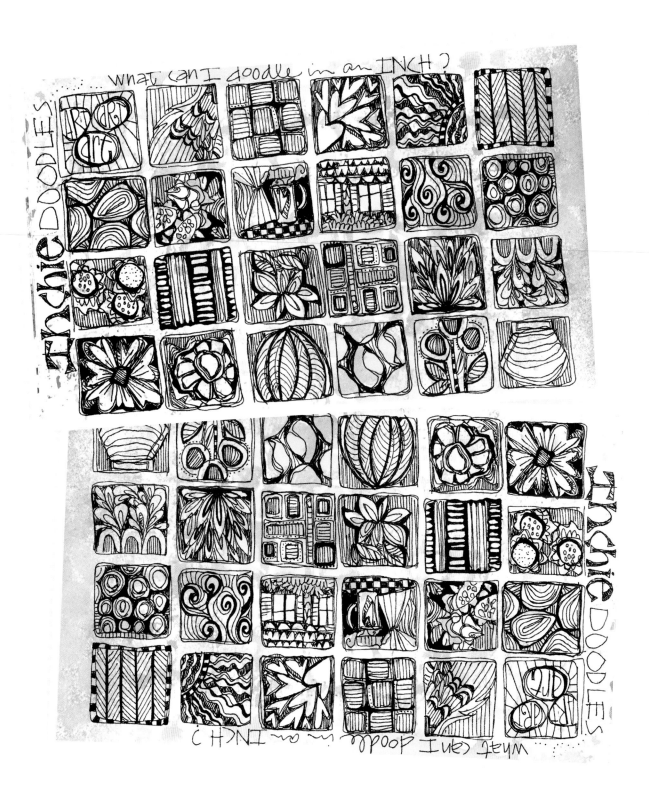

INCHIES

Is a big page too intimidating? Take baby steps. What can you doodle draw in the space of a one-inch square? On two pages in this 5" × 8" sketchbook I have created 48 little art works! These little layouts can become larger pages or even full size doodled paintings on canvas. Draw and doodle objects and patterns, increasing details and adding more and more elements. As a resource, use the "inchies" as reference for new art. A single small idea can lead to your next big thing.

DOODLE LETTERING JOURNALS

I really love words. For my whole life as an artist, my personal expression has been to let my art speak by artfully crafting doodling, drawing and painting each piece. To me, if a piece doesn't include words or a sentiment or message, it just doesn't look finished. Adding text with hand-drawn letters gives my art purpose and function, whether it's for personal inspiration or to share with others. The doodle lettering style is a loose interpretation of the alphabet and is perfect for designing stylized word art. Use a sketchbook to practice the limitless possibilities for transforming the alphabet. Freely draw the structure of each letter in pen or pencil and embellish with line art, colorful shapes and decorative pattern, giving words a punch on a page. Get in the same relaxing doodle state, hand-drawing every letter over and over again, combining new elements to create your own font.

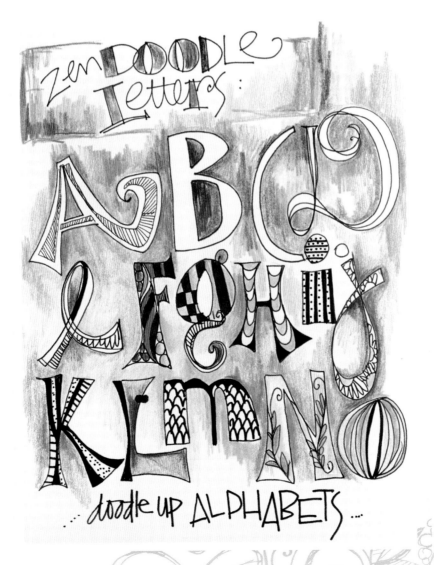

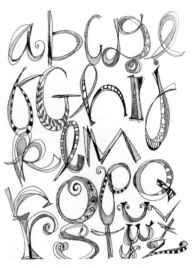

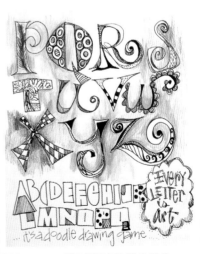

Again, the task of creating dozens of ideas for lettering art might be overwhelming, so keep your ideas streamlined in a small sketchbook. I like the hearty paper in this landscape format Moleskine 5" × 8" watercolor journal. To make little word vignettes, I first pencil in clustered blocks as compartments for writing and lettering. Then I paint or color each background. Each block is different from the next and is its own entity, inspiring ideas for future art.

There are so many ways to showcase and illustrate hand-drawn lettering, such as filling block letters with decoration, doodling a letter and then thickening the form, exaggerating heights and widths, making the letters fit in the entire box, popping words with doodle designs in the negative space, combining print and cursive writing, and stacking words in rows to fill the compartment. It's quite gratifying to flip through your word pages and appreciate your style evolution.

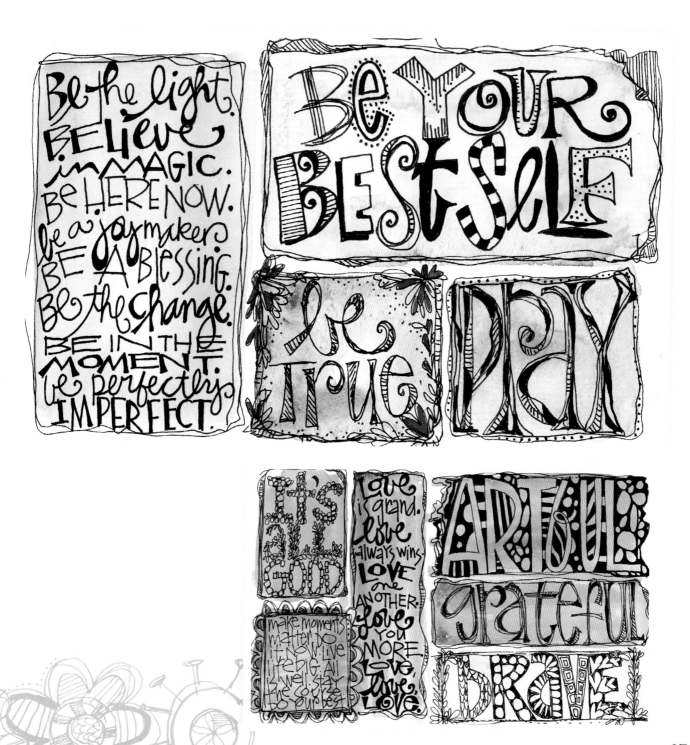

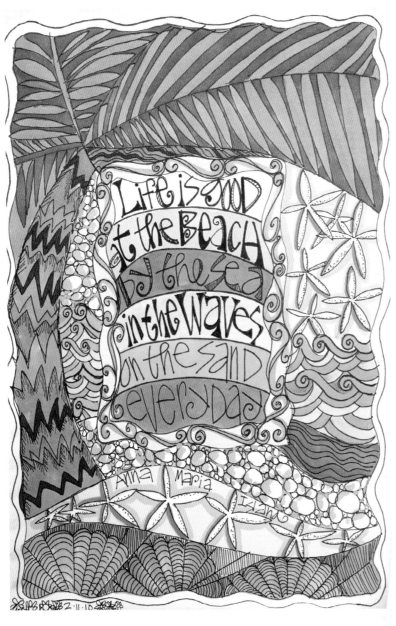

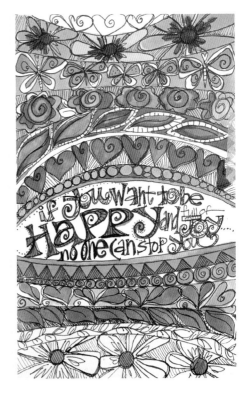

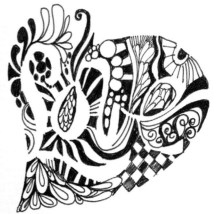

ROW BY ROW

Organize the areas of a page by dividing sections in a landscape
orientation with bent, curved or straight lines. Choose a theme
if desired, and fill each banded area with relevant imagery,
patterns and words to tell a story.

GO ABSTRACT AND ORGANIC

Find inspiration in the abstract. Paint a vertical or horizontal background. Then draw. Doodle. Capture the details and motions created in cracks and crevices. Find inspiration in rock formations and mountainous landscapes. Fill in the channels and spaces with line art, solid black (or color), shapes, words and repeating lines to create free-flowing scenes that spill off the page.

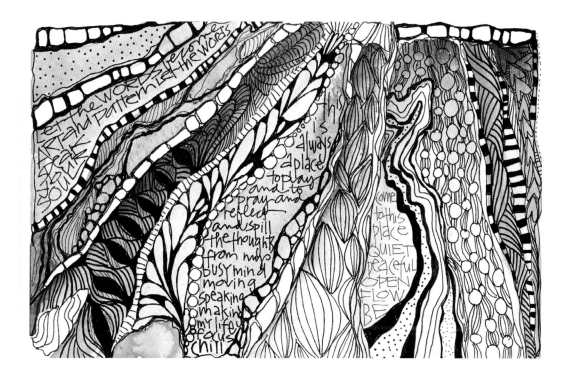

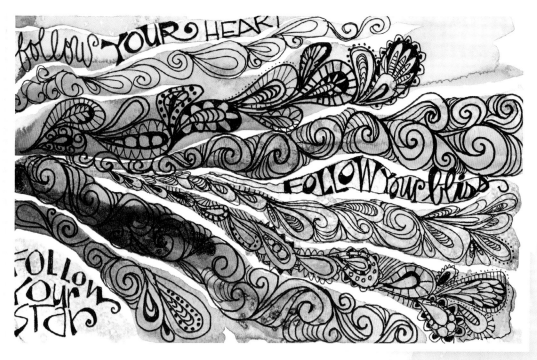

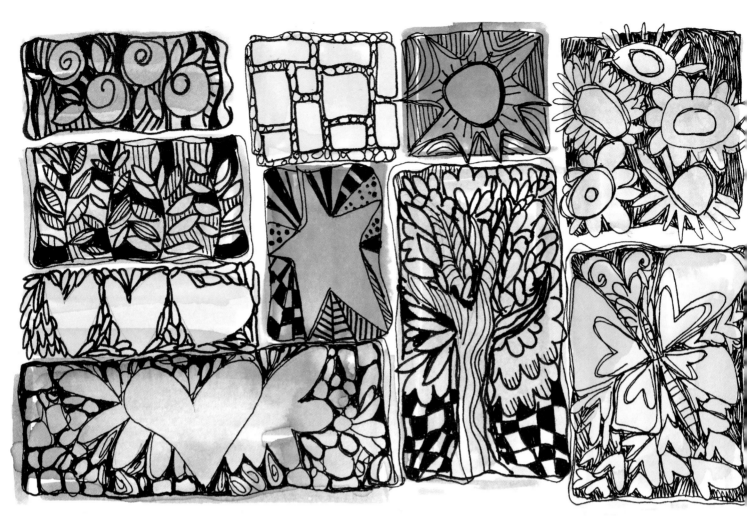

POPPING ART

Draw simple or elaborate line art, and add heavy color and pattern in the negative spaces (the space outside of and around your words and doodles) to create the illusion of images popping out of their frames. This is another great technique for doodling on sketchbook pages.

LETTERING IN SPACE

Words and lettering can become filler art in the negative space of a central image. This piece was created by writing and drawing with a resist pen, adding line art to the positive space. Watercolor shading was added in the negative space and allowed to dried overnight. The resist was then rubbed off to reveal white line art, which was then outlined with a super thin white pen. You have my permission to go overboard and fill in every last area of negative space with handwritten words and lettering, as I have done in this sample in which the writing becomes the patterning.

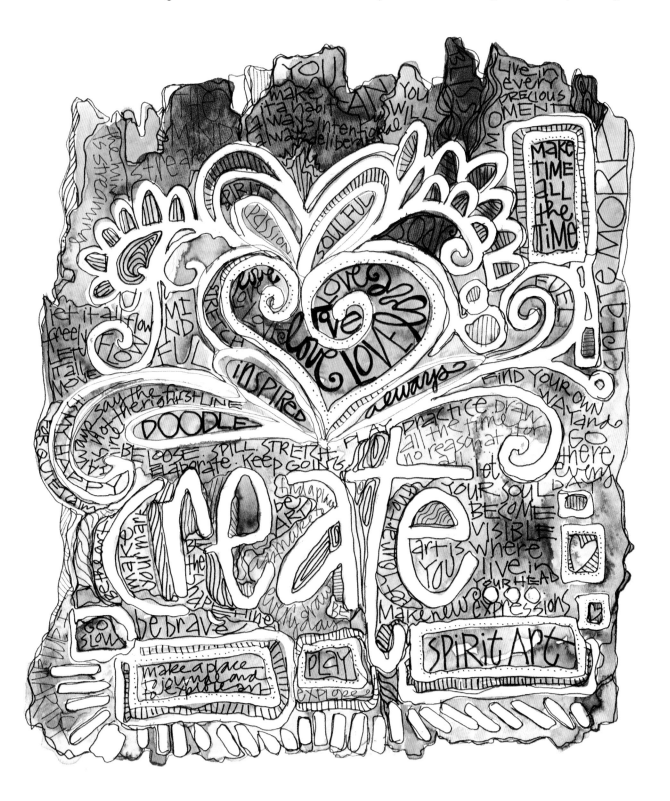

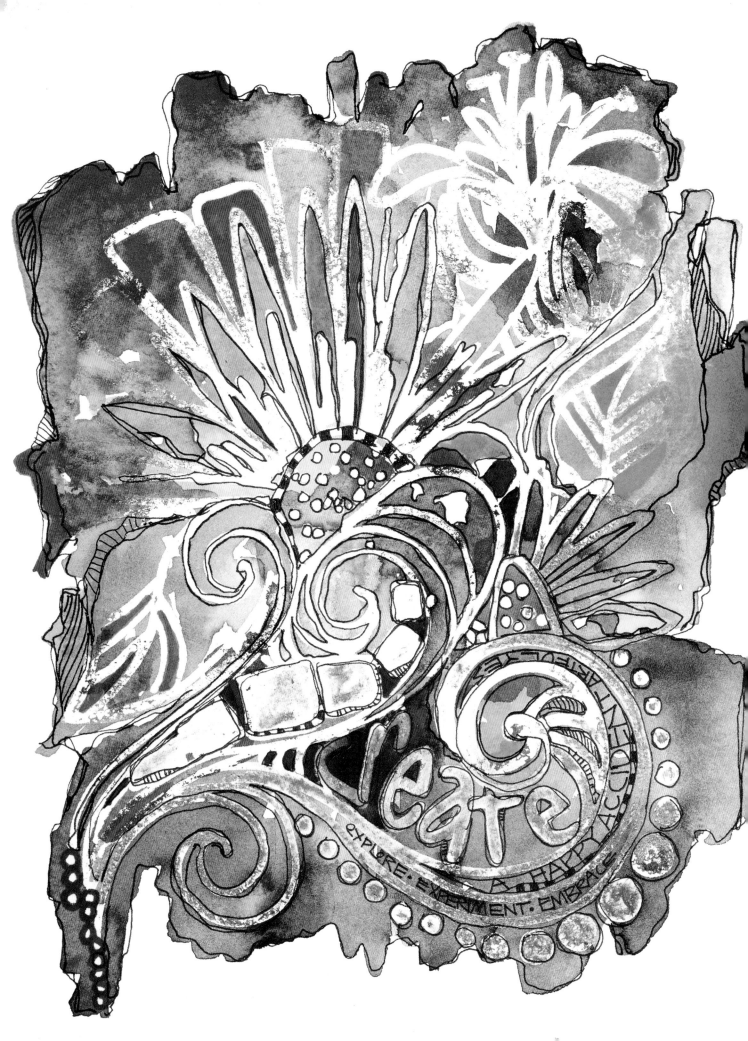

create

EXPLORE · EXPERIMENT · EMBRACE A HAPPY ACCIDENT AR

7 Dabble Doodle in Mixed Media

Doodle art is the ultimate free-spirited process of drawing and art making. Fabulous artworks don't have to be created with just pens or markers, and the same concepts can be crafted with new materials. Mix up your materials to make doodle artworks with an unexpected twist. Use inks, paints, stencils and more to make vibrant masterpieces.

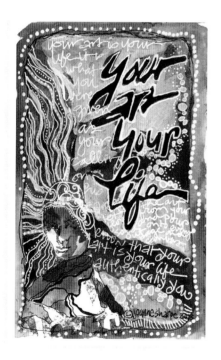 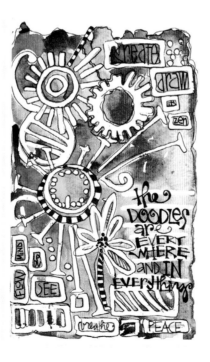 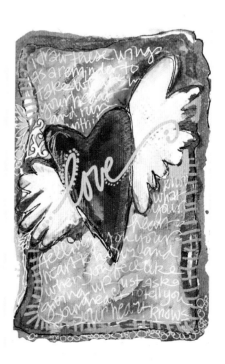

ACRYLIC DOODLE LAYERS

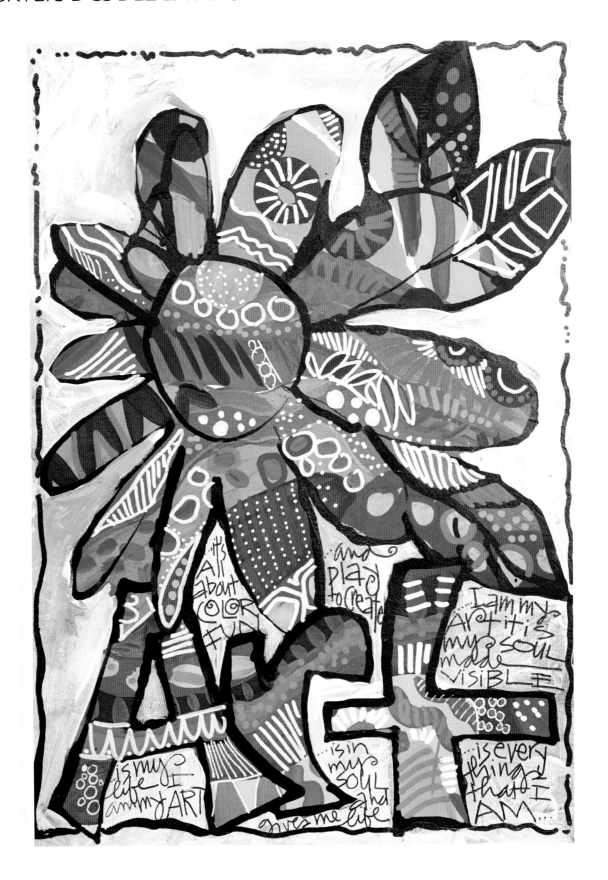

Doodle with a paintbrush, making bold swipes and patterns with acrylic paint to create a layered mixed-media masterpiece popping with color and playful details. Think of the brush as a pen as you draw with paint.

Materials list

PAINT MARKERS

FLUID ACRYLIC PAINTS

WHITE GEL PENS

WATERCOLOR OR BRISTOL PAPER

BLACK PEN

PAINTBRUSHES

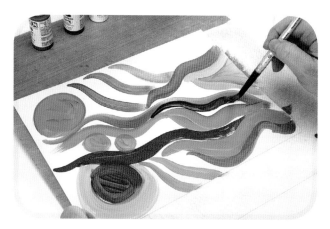

1 Use your favorite colors of acrylic paint to freeform paint a colorful background. Keep your shapes soft and organic and lines dipping up and down and moving gracefully across your paper

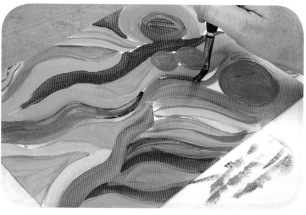

2 Continue painting until you cover the entire paper with a layer of paint leaving, no white space. Let the paint dry.

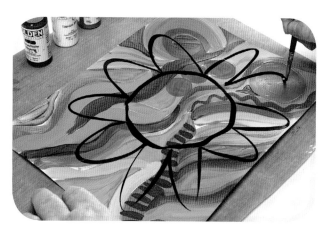

3 Using black acrylic paint and a fine tipped paint-brush (such as a #4 watercolor round), loosely draw a simple image over the background. (I am paint-drawing a flower shape with large petals and leaves.) You can even draw and incorporate the outlines of words into the composition. Let the black paint dry thoroughly.

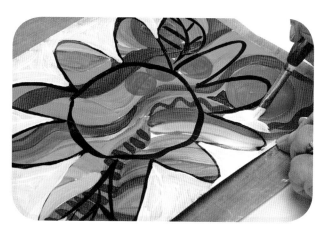

4 Paint the negative space around the image with a light layer of white acrylic paint, and let dry.

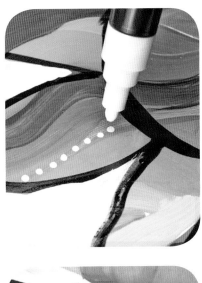
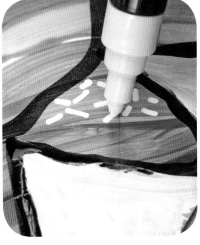
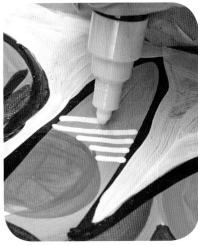

5 Identify all the new patterns revealed in the positive spaces. Use acrylic paint markers to doodle-decorate each new shape individually with assorted marks like dots, dashes, circles and lines.

6 For a crisp clean finish, touch up the black paint outlines of the main shape

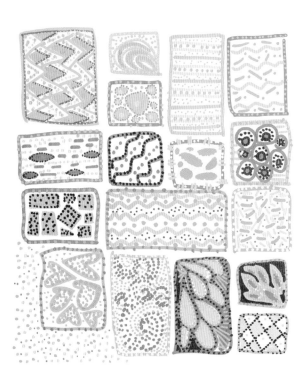

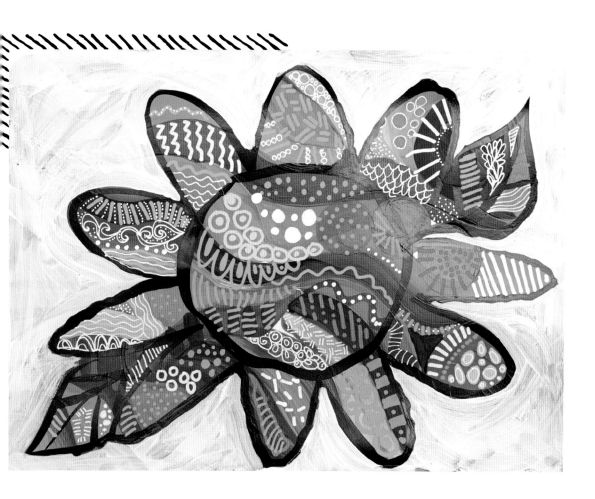

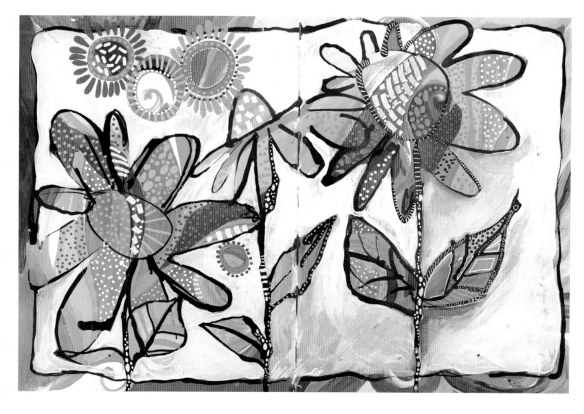

BLOOMING DOODLES | CUT-OUT COLLAGE

"the NEW doodle bloom"

• hand DRAWN and HAND cut

doodle it UP in black and white

Create your own mixed-media doodle art collage with custom hand-cut papers, water reactive spray inks and pens. Use this idea for card making, journaling and decorative wall art. Each spritz of ink over fun paper cutouts provides an artful "wow!"

Materials list

..

BRISTOL PAPER

PENCIL

SCISSORS

WATERPROOF BLACK PENS

DYLUSIONS SPRAY INKS (PINK, TURQUOISE, GREEN)

SPRAY BOTTLE WITH WATER

WATERBRUSH

WHITE SIGNO OR GEL PEN

WHITE ACRYLIC PAINT MARKER

GLUE STICK

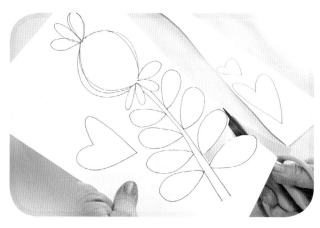

1 With a black pen, draw the shapes of flowers, stems and leaves on bristol paper. Cut out the shapes.

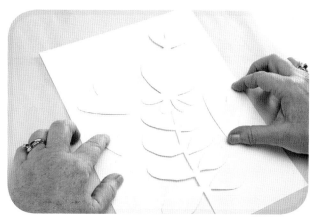

2 Flip the shapes over and arrange them on another piece of bristol paper as desired.

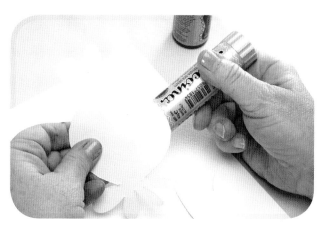

3 Lightly secure them to the piece of bristol paper with a glue stick.

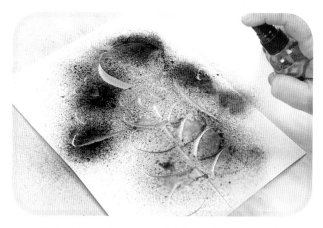

4 Spritz the entire paper with Dylusions spray inks. Let the ink dry.

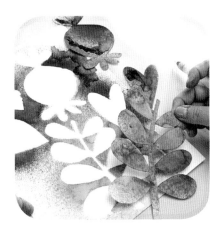 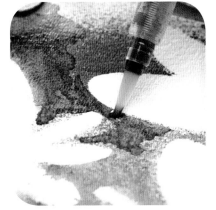 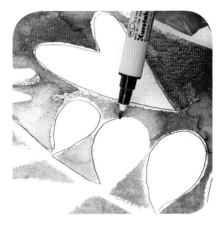

5 Remove the paper shapes from the background paper to reveal white images surrounded by ink.

6 With a waterbrush, go into the negative space around the white images and lightly paint with water to reactivate the ink. A completely new look will appear with puddles of changing colors.

7 With your favorite black pen, doodle inside the revealed white spaces, filling them with loose, sketchy patterns.

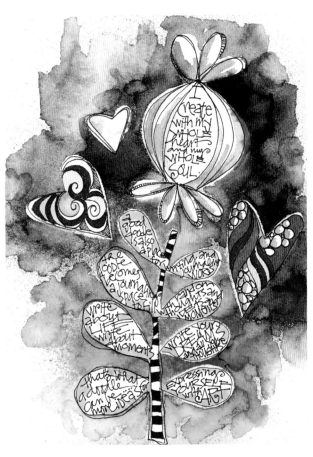 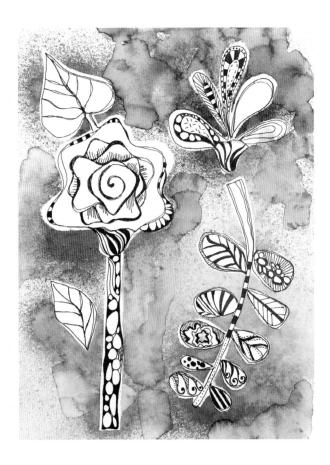

8 Add doodling to the darker ink colors using a white gel pen. (The Signo UM-153 pen works the best for this technique.) Use the spray inked pieces as collage elements for cards or decorative artwork.

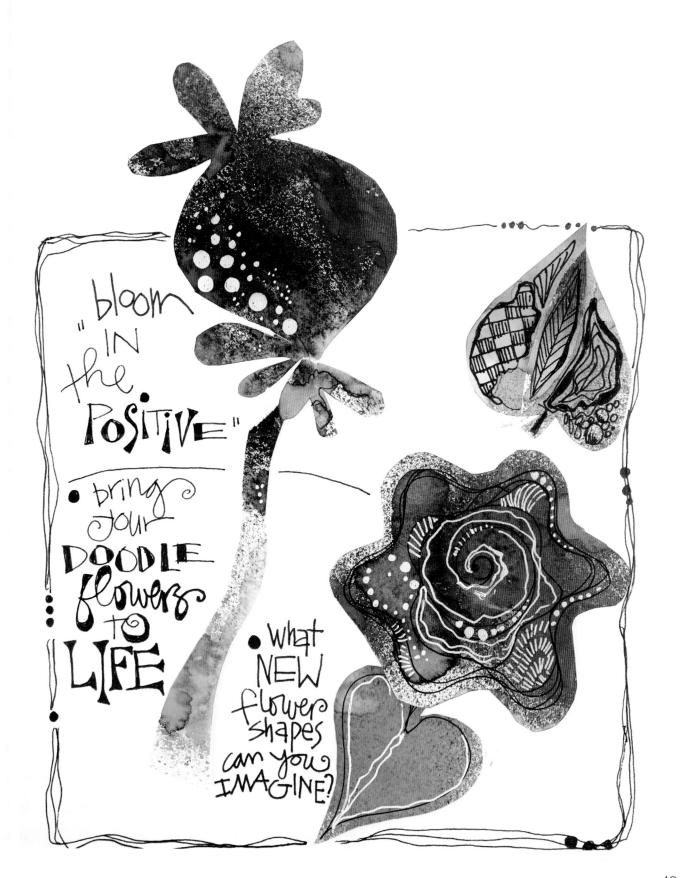

"bloom IN the POSITIVE"

• bring your DOODLE flowers to LIFE

• what NEW flower shapes can you IMAGINE?

STENCIL DOODLES

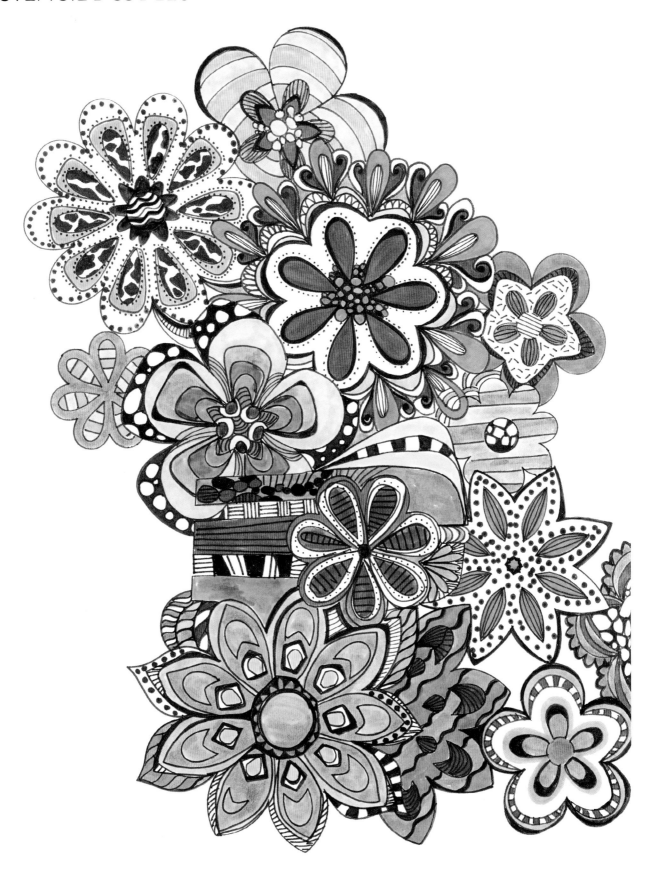

Here's an innovative doodling idea to use with your mixed-media stencil stash for ready-made art pattern ideas. Stencils work as an idea starter or jumping-off point as you begin an elaborate doodle drawing. Add your own spin to the traced patterns. Don't take the stencil design too literally, but make something new. This is a soothing, meditative activity that can be used to decorate journal pages, cards, signs and more.

Materials list

- STENCIL
- WATERPROOF BLACK PEN
- DYE-BASED MARKERS (LIKE TOMBOW OR KOI COLORBRUSH)
- COLORED PENCILS
- WATERCOLOR PAINTS
- BRISTOL OR WATERCOLOR PAPER
- WATERBRUSH

1 Lay a stencil over a piece of paper. Trace inside stencil openings with a waterproof black pen. When you are finished tracing, remove the stencil.

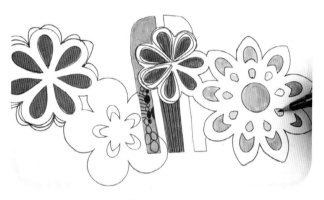

2 Color in the stencil shapes with dye-based markers, colored pencils or watercolors.

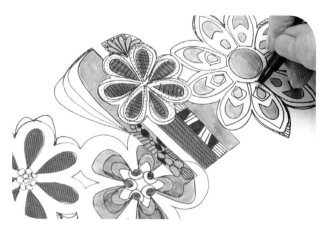

3 Add doodle art to the colored spaces with a black pen.

.: STENCIL TIPS :.

The stencil you use should have lots of big open spaces—small spaces will be difficult, if not impossible, to doodle in. Also make sure the material your stencil is made of isn't too flimsy. Your pen is more likely to skip over the surface of a flimsy stencil, depositing ink where you probably don't want it.

DOODLEY DIMENSIONS

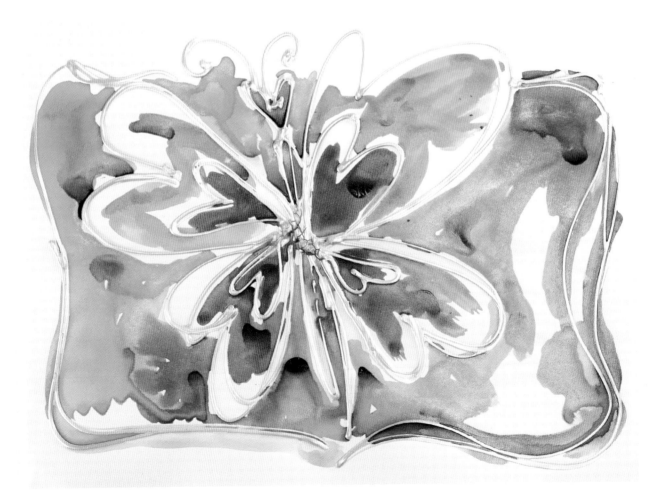

It's a good thing to seek out and discover different art materials to use for doodle art. Explore and experiment with the many brands of permanent dimensional paints. Every mark you make, every line you draw with the thin-tipped paint bottle becomes a thick, raised and textured pictorial outline. This is not a great technique for a journal art, though, as the raised paint often causes pages to stick together when closed inside a book form.

Materials list

BRISTOL PAPER

DIMENSIONAL PAINT

METALLIC OR MICA WATERCOLOR PAINTS

WATERBRUSH

DYE BASED-MARKERS (LIKE TOMBOW OR KOI COLORBRUSH)

PENCIL

VARIATION : WHITE DIMENSIONAL PAINT

1 With a pencil, draw any shape or doodle on a piece of bristol paper. Use white dimensional paint to draw over the pencil lines. Embellish with patterns, lines and dots, if desired. Let the paint dry.

2 Paint inside the lines of the dimensional images using metallic or plain watercolor paints. You can use markers if you prefer.

3 Blot any undesirable spills in the negative space, clearing the way for another layer of paint.

4 Add color to the negative space around the raised image.

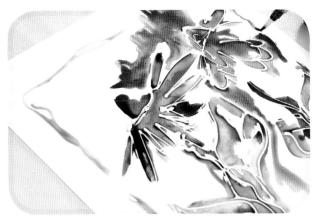

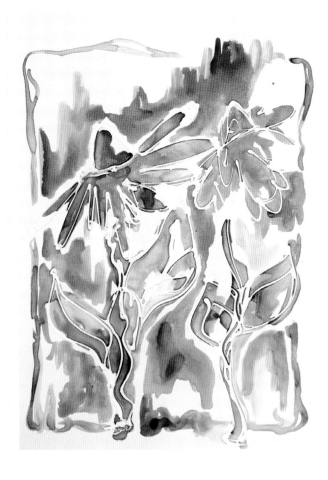

5 Paint a loose whimsical border around the page (the more imperfect, the better). The white 3-D paint lets the paint and color pop, providing great interest to the line work.

VARIATION : GOLD OR COLORED DIMENSIONAL PAINT

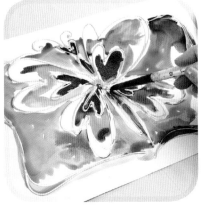

.: GOLD DIMENSIONAL PAINT :.

Even with so many art supply options, you'll still discover your favorites along the way, like all the varieties of dimensional paints, for example. Gold metallic 3-D paint is one of my personal favorites. It provides a soft and shimmering effect on cards, paper and canvas word art.

1 The steps for using gold dimensional paint are the same as for using white dimensional paint: Draw your doodle in pencil and trace over it with dimensional paint. Or if you prefer, go ahead and sketch directly on the bristol paper with the paint. Let the paint dry.

2 Paint inside and around the dimensional line work with your choice of watercolors. Be brave and use the dimensional paints, with a fine tip attached, to draw a loose, sketchy frame around your main image.

VARIATION : BLACK DIMENSIONAL PAINT

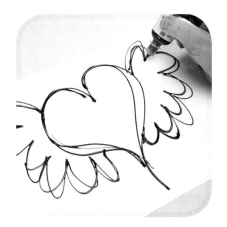 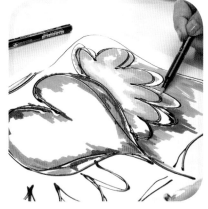 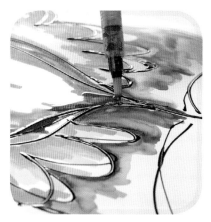

1 The steps for using black dimensional paint are the same: Draw your doodle in pencil and trace over it with dimensional paint. Or if you prefer, go ahead and sketch directly on your bristol paper with the paint.

2 Try using dye-based markers to add color to your dimensional imagery. Fill in the spaces with bold marker color. Then activate the ink by painting over it with a waterbrush to achieve a watercolor effect.

3 If desired, when your marker work is dry, you can add a layer of watercolor or metallic watercolor to accent and add more texture to the color and brushwork.

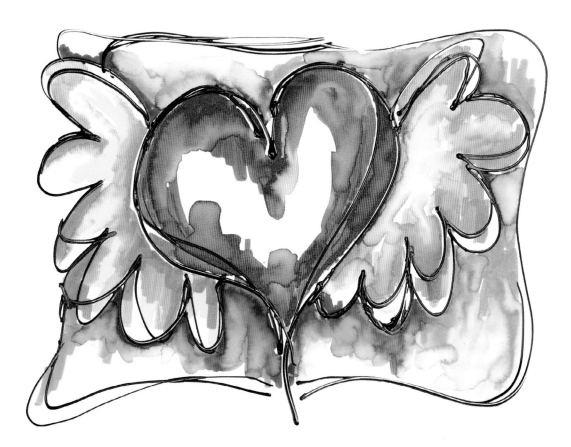

BLACK DIMENSIONAL PAINT
If you are looking to achieve a look that mimics your black pen work, try using glossy black dimensional paint. The best part of this technique is filling in the areas with color, with the raised lines acting like barricades holding in puddles of paint.

IRRESISTIBLE DOODLES

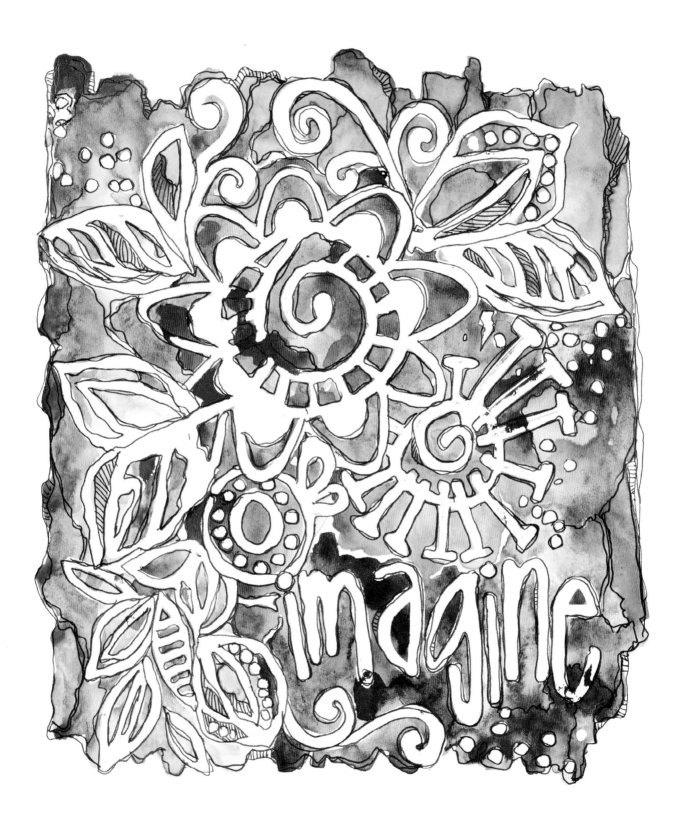

Another fun discovery along my art supply hunting journey is the Molotow Graphx Art Masking Liquid pump marker. This is a marker filled with a rub-off resist substance for use on paper surfaces. This terrific doodle tool creates white lines and spaces that are just begging to be filled with doodles.

Materials list

· ·

MOLOTOW RESIST PEN

WATERCOLOR PAPER

WATERCOLOR PAINTS

1 Draw your doodle art with the resist marker, filling up a page with pattern and design. Let the marks dry. Your doodle drawing will appear blue on your paper once it has dried.

2 Paint over your drawing with watercolor paints, and let the paint dry completely.

3 Rub off the blue resist ink to reveal unpainted white paper. Embellish the white areas as desired.

.: THE MOLOTOW RESIST PEN :.

You'll find this product where fine art supplies are sold. Follow the manufacturer's instructions for use and care. After I draw and letter with the marker, I allow the resist to dry for at least 45 minutes, and then I paint my page with watercolors. Let the paint dry. Then rub the resist substance with a clean cotton cloth to remove it.

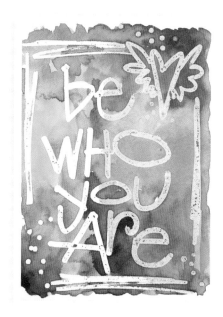

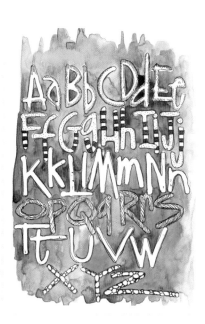

8 DOODLE JOURNALS

You might still be thinking, "What's the point to this doodle art thing?" Of course you will make your own decisions and find your own personal reasoning for this practice, but I can confidently say that doodling—or any art making for that matter—gives you a freedom to carve out a place in time and solitude to gather your thoughts and give them life. This can be a quiet meditative activity or an energetic art jam session with your favorite music blaring. That all might sound a little weird or crazy, but sometimes you have to remove yourself from the mundane and ordinary in order to make extraordinary moments. Technology is one of the biggest obstacles, robbing us of time that we could be spending making beautiful things with our human hearts and hands. I have a little painted note on my desk that I see every day that reads "Get off the computer and walk or paint or draw!" That message holds the all the logic and reason for making time for self-expression and reflection. In a nutshell, it's a good thing for *you*. Start making your doodle art journal and sketchbook collections right now.

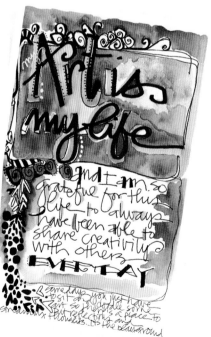

ARTFUL ABSTRACTIONS

Once the fear is gone, there's something about putting a pen or pencil to a blank sheet of paper or brush to an empty canvas that is invigorating. Starting out with art that is more abstract than realistic might provide the confidence needed to silence your inner critic, allowing you to begin. The art of abstraction does not have predetermined visual results; it is an expressive response to making art, rather than the rendering of a subject perfectly for instant recognition.

No matter how you choose to nurture your style, you'll know when it strikes. It will be effortless, smooth, pleasant and energizing, and your true identity will make itself known. You might at first struggle with drawing or painting if you are trying to imitate an artist or teacher exactly. As a teacher, I provide my students with techniques and projects to inspire their own personal creativity and build foundations for the development of personal style.

I share all my journals, as each one showcases art that is imperfect, messy, smeared, sloppy, awesome and breathtaking all in one place. Each journal demonstrates the practice of moving forward, growing and stretching my art muscles every day.

Choose a good quality commercial art journal or sketchbook for the therapeutic daily practice of doodling with paint and color.

Experiment painting intuitively with color, shape with repeating lines that are circular, linear and organic, and pattern fill each page until there is no visible white space.

Embellish with painted patterns, words or drawings with a white gel pen, metallic paints and paint markers.

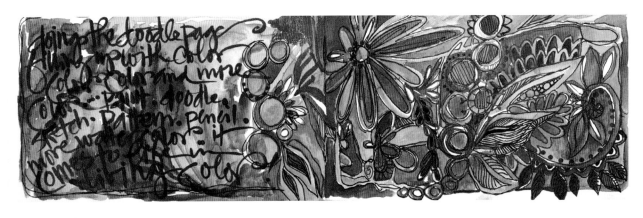

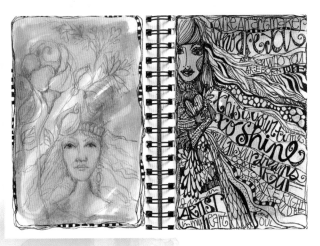

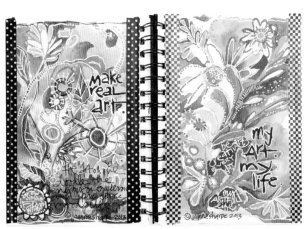

Here is a sampling of my elaborate art journal collection illustrating all my ideas the techniques in action. This my happy place! These journals and sketchbooks are various sizes and the pages are doodled, painted, lettered, drawn, sprayed, colored and sketched.

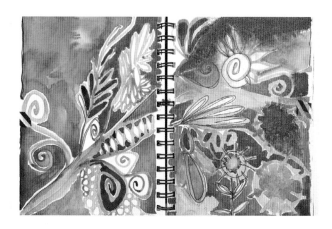
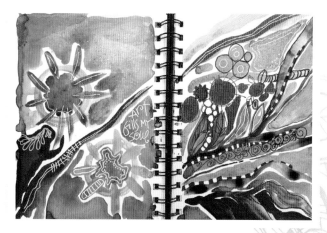
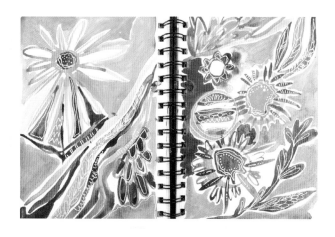
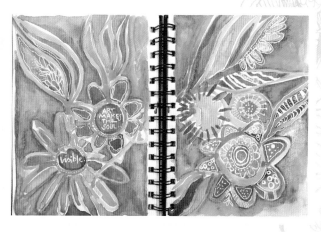
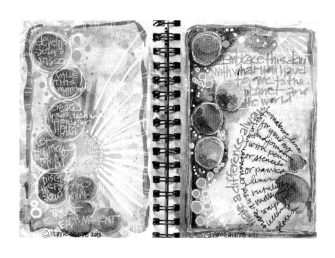
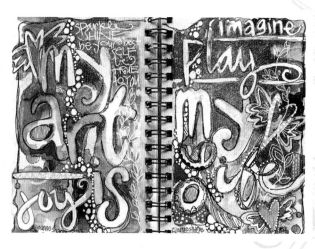

DOODLE SPILLING EVERY DAY

Each day provides a new opportunity to respond to the world around us. Because visual memory is so powerful in our psyche, keeping a daily sketchbook or journal is beneficial to recalling and documenting day-to-day experiences. If you are creating a doodle art journal, you don't necessarily have to be concerned with making perfectly rendered accounts of subjects, but freely and loosely draw and letter images to capture the emotions or information associated with the events of the day. Hand-letter a full journal page using a phrase or thought that reflects the mood or event of a specific day. Let the page flow, recording your thoughts with your handwriting or small doodled drawings to add character. No one has to see your work. Or you might want to share it with the world. Either way, let your art spill out!

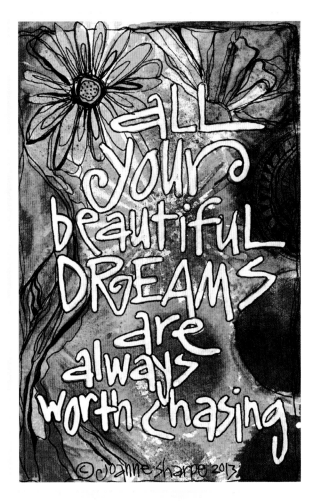

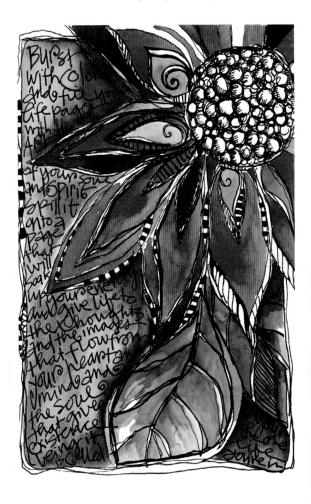

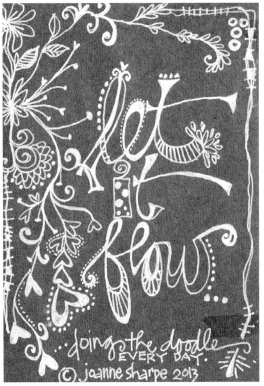

Make your doodle art habit a priority, and keep basic supplies handy so you can create something in a small journal or sketchbook every day. Some days you'll feel like drawing every little detail and writing about them all, and other days you might prefer to just doodle, draw, paint and color the page and hand letter inspiring phrases, quotes and sentiments.

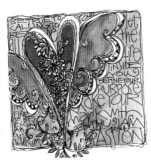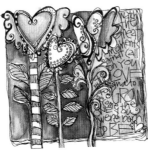

A day to doodle my whimsical hearts and funky flowers with watercolor and freeform hand lettering filling in the negative space around the art.

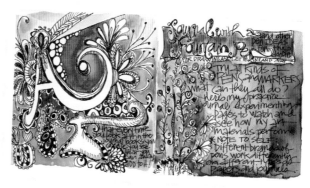

Black and white lettering brainstorm with painted marker color popping the art off the page, with handwriting of random ideas and recalling the details of what I was creating on the page.

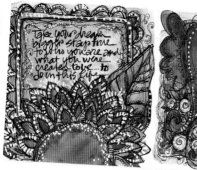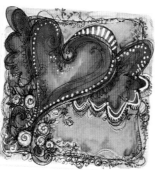

Over doodling with watercolor, black line art and white paint pen with hand-lettered thought.

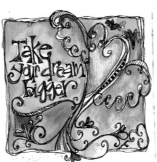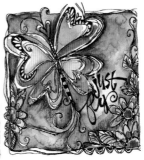

Black line art with a waterproof pen and dye-base marker (Tombow) activated with a waterbrush to create a light wash on the page.

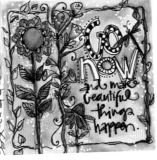

Writing my name in script and transforming it into a colorful abstract image filled in with pattern with a corresponding page illustrating a favorite quote.

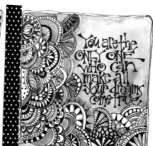

Simple and elaborate pages with busy doodled border in a composition on the left side and along bottom of each page with large openings left for writing and lettering.

PHOTO-INSPIRED DRAWING

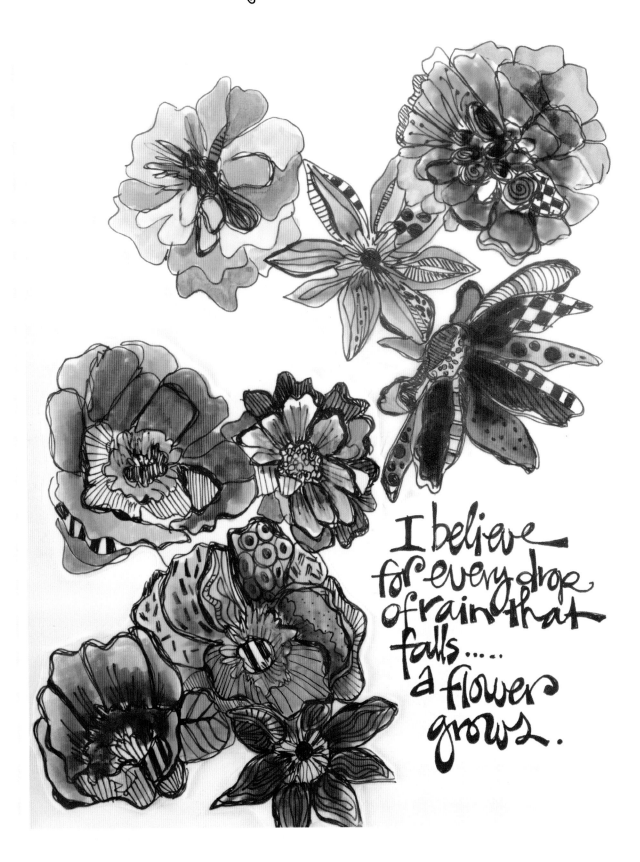

I believe
for every drop
of rain that
falls.....
a flower
grows.

It's okay to get stuck when you're trying to think of ideas for imagery in your art. A successful technique to start the creative juices flowing is to use your own personal photos. Your cell phone or camera can be the handiest of tools when seeking inspiration and finding subjects that have the best potential to become art themes and details. As I have suggested in previous chapters, everything can be an idea for art. I tend to photograph nature, like flowers, foliage and landscapes, and I transform them into my own personal whimsical interpretation as demonstrated in the technique below. Use your favorite personal photos or magazine images as inspiration for design and pattern development for your drawings.

Materials list

LARGE PHOTOS

TRACING PAPER

BLACK PEN

LIGHT BOX (OPTIONAL)

WASHI TAPE

MARKERS

PENCIL

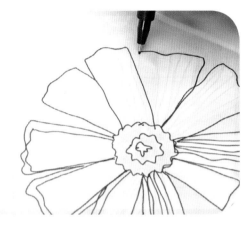

1 Place a piece of tracing and place over your photo. Trace the details with a black pen.

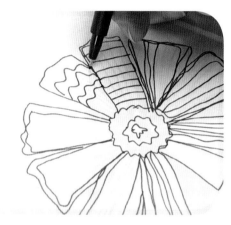

2 Interpret details as you draw: Add lines and doodles within the larger shapes and spaces of your subject.

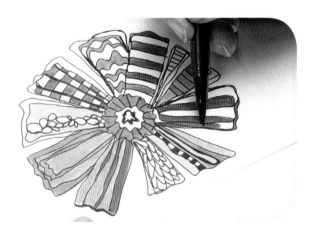

3 Continue to interpret the image as your own by embellishing and coloring as desired.

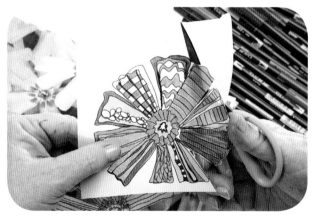

4 Cut out your image and lightly paste it onto a journal page or other artwork using a glue stick. These photo inspired images make excellent collage elements.

VARIATION : USING A LIGHT BOX

A light box is another essential tool that I have in my studio. It's a device that comes in several sizes and is used for hand tracing photos or drawings as light shines beneath traceable images. While I am all about making my own original drawings, a light box helps in training your muscle memory to make specific marks. You can trace photographs of your own artwork as subjects for a new piece and even replicate that art several times (to place on one page, perhaps). I know we can do this with Photoshop, of course, but this process is for handwork, not digital art. This is very convenient when I want to reproduce one drawing and place it somewhere else. I can take drawings or doodles from sheets of paper and use the light box to transfer that image directly onto a page in a bound journal. The light box is very handy for reproducing lettering art as well. It's genius!

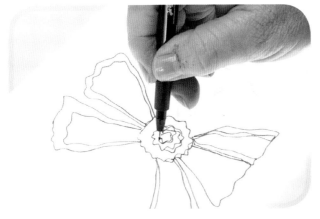

1 Use a light box to trace the photo with pen or pencil onto art paper or a journal page.

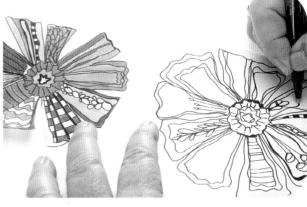

2 Once the basic shape has been traced, remove your paper from the light box and add doodles and designs.

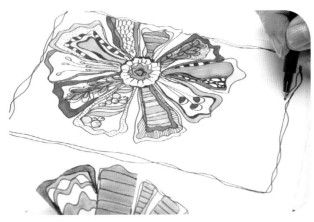

3 Now that you have your image transferred to where you like it in the journal, change it up a little bit: Embellish, decorate and color. The light box is just another tool to transform doodle art.

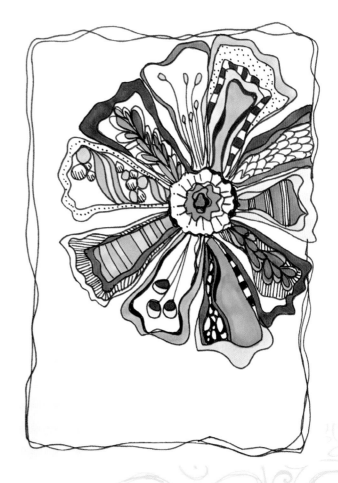

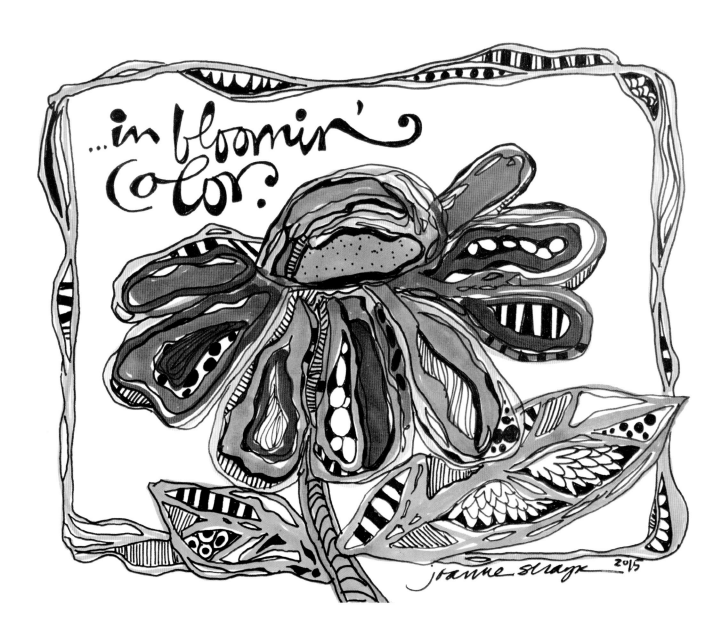

...in bloomin' color.

joanne strayx 2015

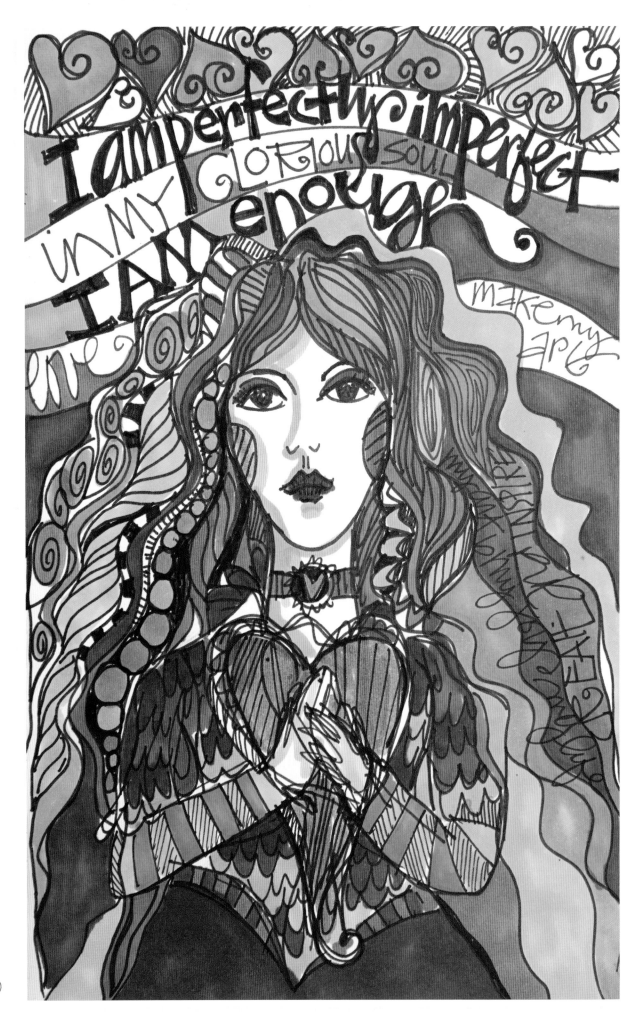

9 Doodle Idea Gallery

Once you get into the "doodle groove," with all your art supplies like pens, paper, markers, paint, journals and sketchbooks, the possibilities are endless. In this book I have shared dozens and dozens of ideas for projects and personal expression. The sample art and activities are presented as inspiration for you to recreate your own illustrated world. Challenge yourself to think beyond what you see and practice, think past what others have done to make your own artful footprint.

It's essential to my own personal well being to be constantly creating, every single day, whether it is drawing, doodling, painting or stitching. It doesn't have to be a giant painting that will hang in the Louvre someday, or king-sized finished quilt, but as long as I have done something creative, be it ever so tiny or grand, I find great satisfaction to settle into my everyday life. I love doodling because there really are no rules, just opportunities to put into motion feelings or thoughts with a visible response. Add freeform, expressive doodle lettering to let your art "speak.".

My theory of doodle art and drawing letters lies in the premise that the process is much more meaningful than the project. Expanding your art skillset with new

ideas and creative process leads you to the development of your own style for personal satisfaction or sharing with the world . It's perfectly fine to copy a technique to master a "look", but go beyond that experience and challenge yourself to find your own authentic voice. If you find something that's appealing in the samples I have shared, practice the techniques but then think beyond them and come up with your own version and interpretation. When the process flows from your hand and spirit in any form, your soul is made visible, even if it's just in simple, playful doodle art and whimsical words. Go play!

DANGLING DOODLES

Give your doodle art some character by putting a new spin on the orientation of a drawing. Rather than fill an entire page with art in a neat composition, stream objects vertically, giving them movement and purpose. This style reminds me of funky, artisan jewelry that might be on display in a gallery.

Materials list

ART JOURNAL OR SKETCHBOOK

BLACK PIGMENT PENS

PENCIL

ERASER

NONBLEEDING MARKERS

COLORED PENCILS

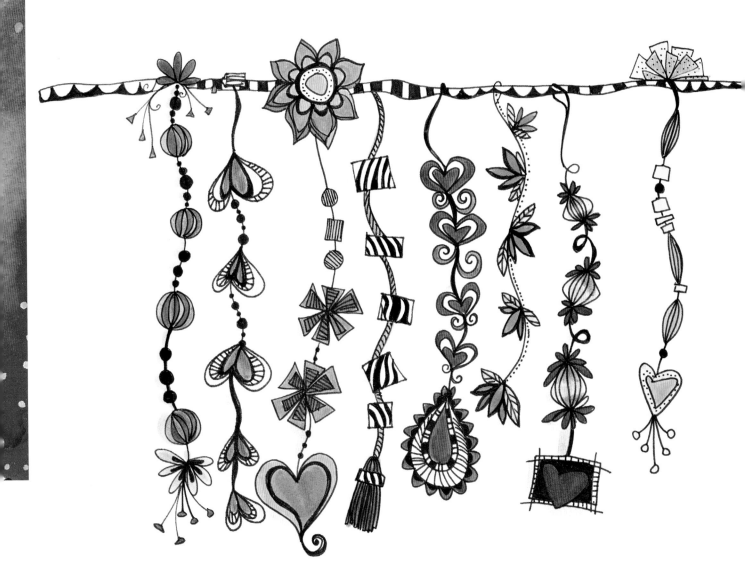

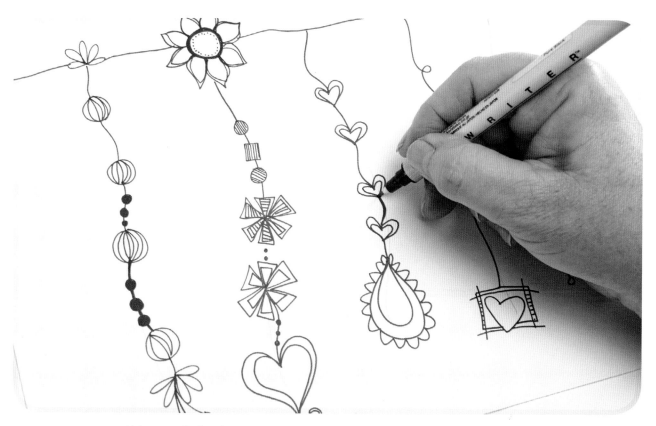

1 Using pencil, sketch vertical lines streaming from a horizontal line drawn near the top of the page. With a pencil or black pen, add pictorial elements like geometrics, stars, flowers and hearts to the dangling lines. Color as desired.

.: LET IT FLOW :.

This drawing idea would be perfect for holiday cards and decorations. Design strings of ornaments that will adorn the front of a card or decorate an envelope. Try this technique with sparkle or glossy gel pens, add metallic dots and lines to mimic string or chain. You could even draw a series of dangles with dimensional paints, cut them out and use as paper tree ornaments.

LEAFY NATURE DOODLES

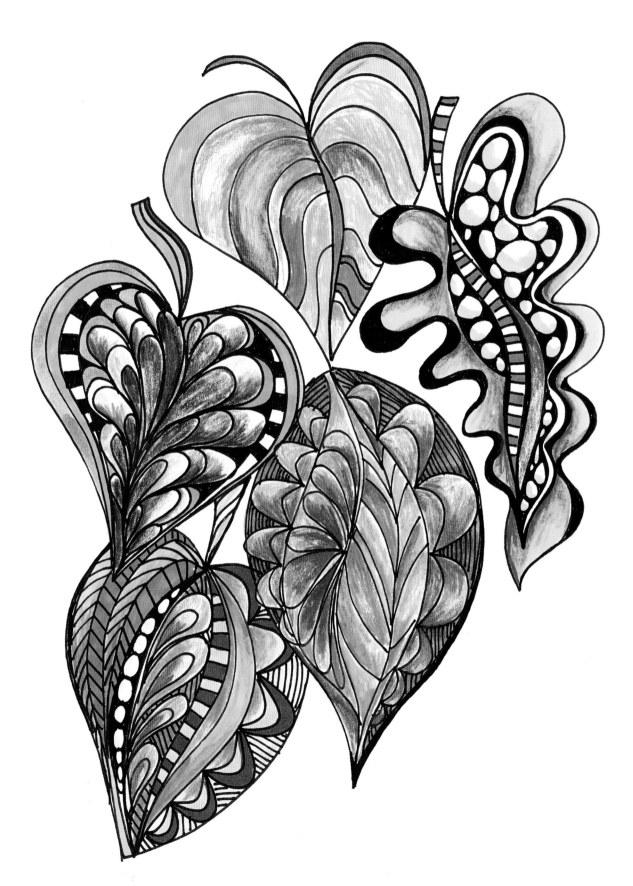

Find inspiration in the shapes of leaves and ferns to create doodle art. The characteristics of natural elements make for wonderful details that can be translated into doodle forms.

Materials list

..

BLACK PEN

PAPER

PENCIL

COLORED PENCILS OR MARKERS

PHOTOS OF PLANTS AND LEAVES

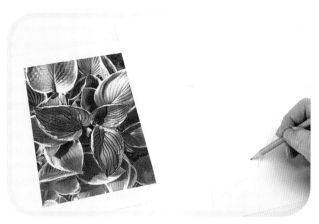

1 Use live leaves, ferns or plants or photos of them to understand and capture the details and characteristics of foliage. Sketch shapes in pencil onto your paper.

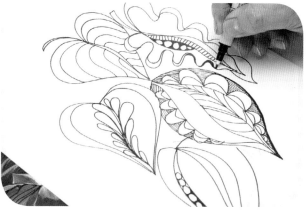

2 Draw over your pencil lines with ink and elaborate by adding lines and doodles.

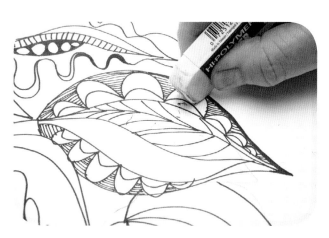

3 Erase any visible pencil lines.

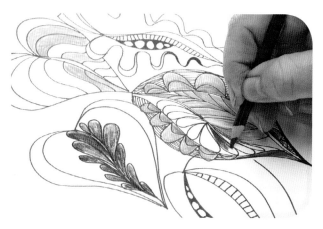

4 Fill in with color using markers and colored pencils.

DOODLE ROOTS AND TREES

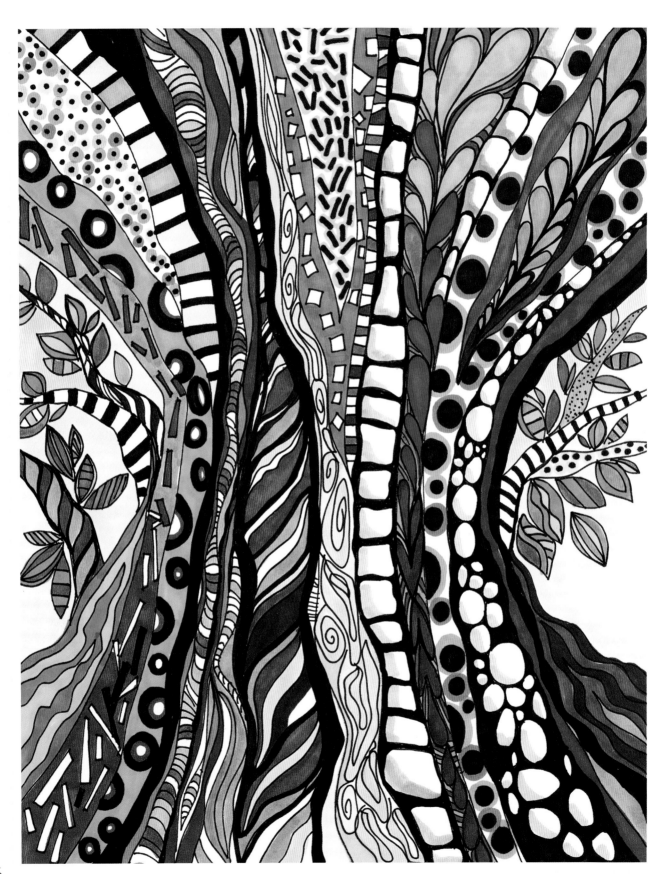

Explore the repetitive elements of the roots and bark of trees to inspire interesting lines, channels and patterns to transform a doodle and make abstract art.

Materials list

..

BLACK PENS

PAPER, ART JOURNAL OR SKETCHBOOK

PENCIL

COLORED PENCILS OR MARKERS

ERASER

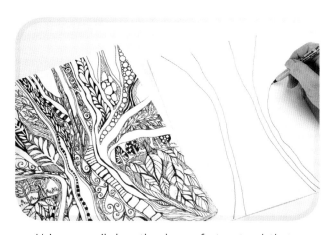

1 Using a pencil, draw the shape of a tree trunk that spreads side to side across a piece of paper or journal page. Fill in the trunk with narrow channels that echo the shape and line of the trunk.

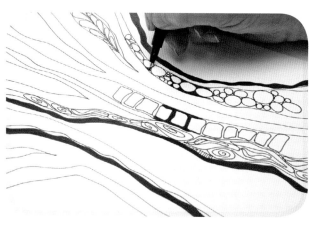

2 Add patterns and doodles to the channels to give volume to the image. Color as desired

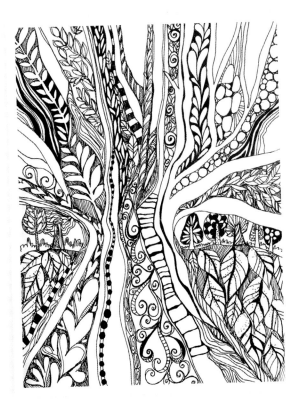

.: PATTERN CHANNELS :.

This is one of my signature art journal doodle techniques. Now that dozens of repeating lines have created so many interesting channels to fill, what should you draw? Here is where you call on your supercharged imagination, challenging yourself to come up with a plethora of options of imagery to use. Make a list of 25 filler patterns and drawings to use. Here are 15 ideas to get you started. Draw:

- swirls
- bricks
- vines
- bubbles
- polka dots

- seeds sprinkles
- hearts
- leaves
- pebbles
- stripes

- water
- raindrops
- mini trees
- pea pods
- bark

DOODLE HEARTS

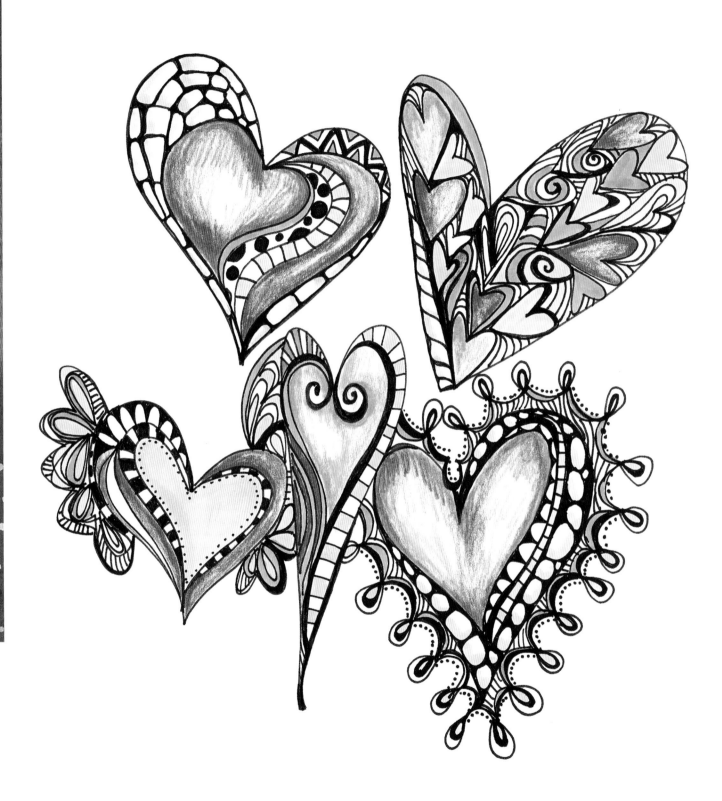

The heart shape is one of my favorite shapes and icons to draw, and it appears in much of my artwork It's a comfortable structure that is easy to render, decorate and transform. It's a recognizable image and has much meaning and significance to an audience.

Materials list

...

BLACK PENS

PAPER, ART JOURNAL OR
SKETCHBOOK

PENCIL

COLORED PENCILS OR MARKERS

ERASER

1 Start with a pencil drawing of basic heart shapes. Be sure your hearts are a variety of sizes.

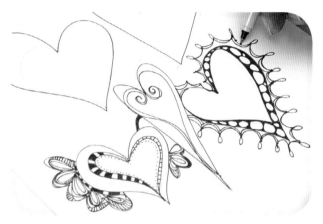

2 With a black pen and layers of line, emphasize the shape of each heart and make compartments to be filled with patterns and doodles. Color however you like.

.: ARTFUL HEARTS :.

Make a 100 Hearts series! Set up 4-6 journal pages designated for a new collection of doodles with a hearts or heart theme. Or, if hearts aren't your thing, choose your favorite image, like birds or flowers, and make your own series. Each time you draw the image, change the shape and size, and add new lines, unexpected patterns and doodle decorations. Embellish the hearts with decorative edges and little drawings.

DOODLE O'S

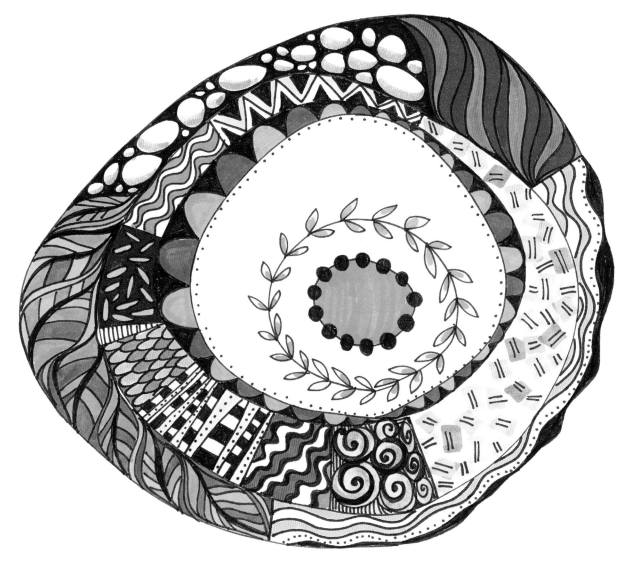

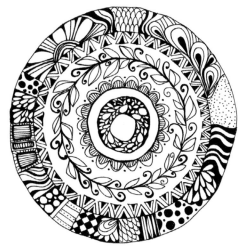

130

Draw two different types of circle shapes as forms to contain doodle art and patterns, one created using a compass and the other drawn freehand for a more organic, fun doodle.

Materials list

BLACK PENS

PAPER, ART JOURNAL OR SKETCHBOOK

PENCIL

COLORED PENCILS OR MARKERS

ERASER

COMPASS WITH PENCIL

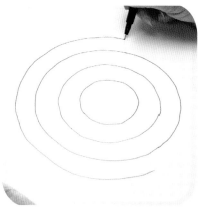

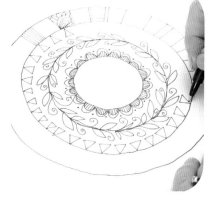

1 Using a compass outfitted with a pencil, draw a set of concentric circles.

2 Trace over the cicles with a black pen. Erase any unwanted pencil lines.

3 Doodle and add patterns both to lines and inside the compartments made by the lines. Color as desired.

VARIATION

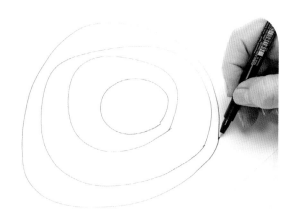

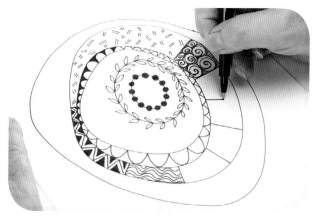

1 Using a pencil, freehand sketch a large but irregular circle shape. Draw smaller concentric circles inside the large circle. Commit to the lines by tracing over them with a black pen. Erase any unwanted pencil lines.

2 Doodle and add patterns both to lines and inside the compartments made by the lines. Color as desired.

DOODLE IN THE LINES

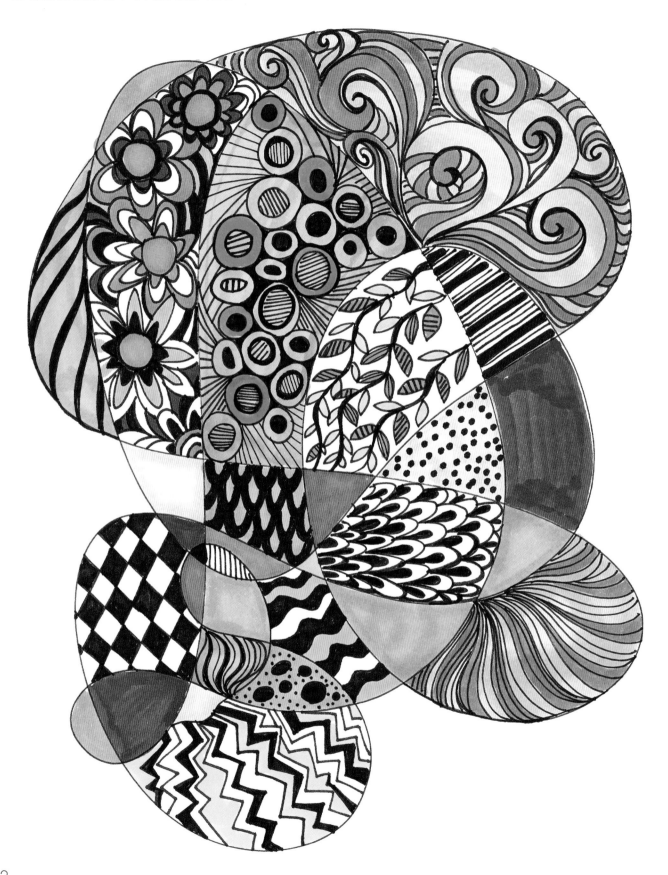

Make deliberate, intentional scribbles as a foundation for abstract doodle art. Let your lines flow smoothly, with gentle, swirling motions, and the entire page area side to side and top to bottom. Make sure the loopy image is closed and that there are no openings; you want all your compartments to be contained. Let your lines flow to yield a controlled and elaborate but loopy scribble, creating new shapes and compartments for doodles.

Materials list

BLACK PENS

PAPER, ART JOURNAL OR SKETCHBOOK

COLORED PENCILS OR MARKERS

ERASER

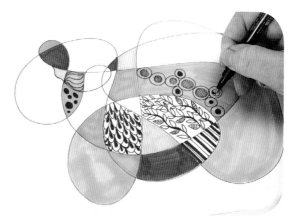

1 With a black pen, let loose and make a large, open scribble on your paper. Cross over lines, creating compartments. Move your pen slowly, cross over the lines creating various-sized compartments for adding doodles.

2 Fill in each shape with marker or colored pencil and embellish with black line art.

.: DOODLE TUNES :.

Move and groove to music as you draw. Loopy doodle design art is a good meditative or quiet activity. Put on some of your favorite soft, chill music and doodle draw the to the sounds and emotion of the music.

DOODLE PATTERN SAMPLER

Work with your doodles and make pattern samplers. Elevate the look of the work you do using a combination of all the doodle art techniques, combining materials and still letting loose. In tandem with pen drawing and sketching images on a page, use tools like stencils, paints and inks for backgrounds, and place doodle work in the shapes. Find unexpected ways to compartmentalize patterns and lettering and use a fine-tip pen to decorate the circle shapes and also the negative space.

Materials list

BLACK PENS

PAPER, ART JOURNAL OR SKETCHBOOK

COLORED PENCILS OR MARKERS

ERASER

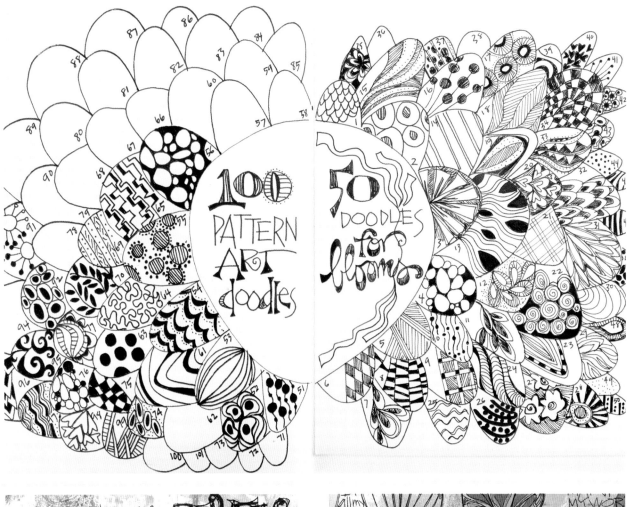

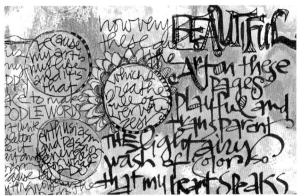

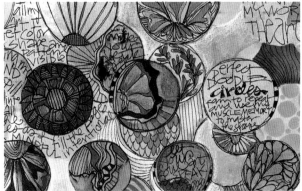

"THE PATTERN BANK"

(black + white)

pebbles and bubbles

lines allover repeating

swirls and dots

scallops/ feathers

(color)

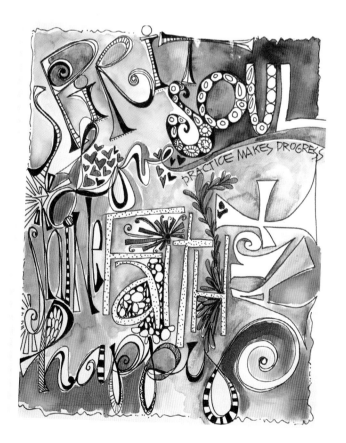

DRAW DOODLE LETTER SHAPES AND FILL WITH PATTERN.
Fill in the negative space in the layout to help the words pop.

FRENCH CURVES

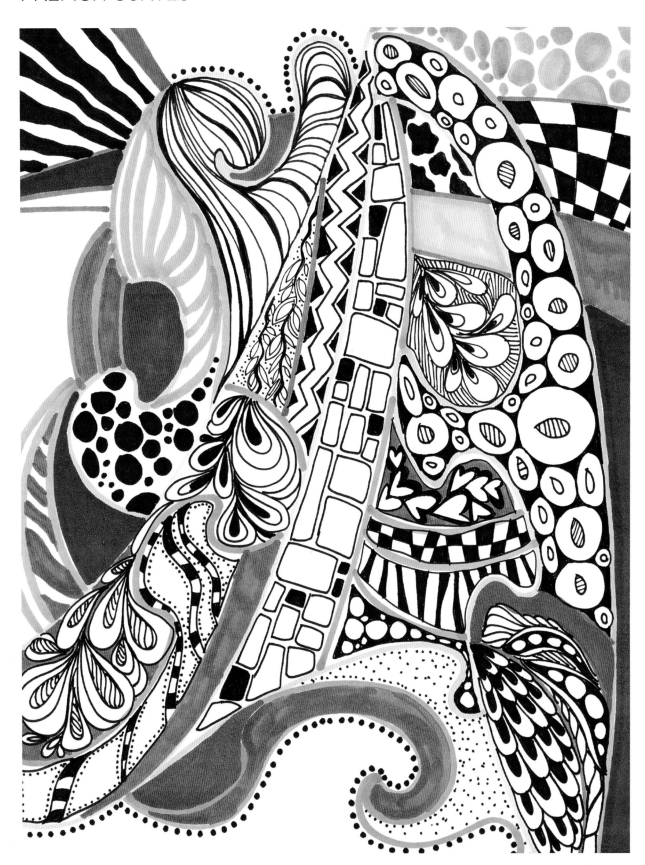

Growing up, my dad was a draftsman and I always enjoyed his table of cool measuring tools, especially the shiny plastic French curves. Before Photoshop and digital manipulation, this curved drawing gadget, like a ruler, was the professional way to hand draw perfect curved lines. Today, you can find sets of these in office supply or fine art stores. Even thought I am not a "ruler girl," in a throwback to my dad's profession of the 1960s I wanted to explore this tool in my doodle art. A French curve is a great tool that allows you to make structured lines that feel organic; they're a great boost to your line-making confidence.

Materials list

..

FRENCH CURVE

PEN OR MARKER

BLACK PEN

WATERCOLOR PAINTS

MARKERS

COLORED PENCILS

WHITE GEL PEN

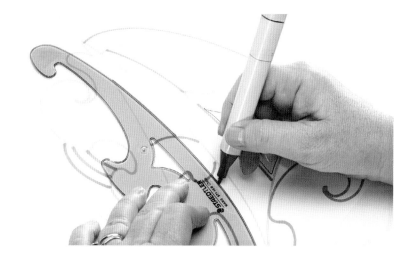

1 Using a marker, trace along various edges and curves of the French curve. Turn the paper and trace more lines, overlapping lines as desired. Let your mind flow, and move the tool to create a web of lines.

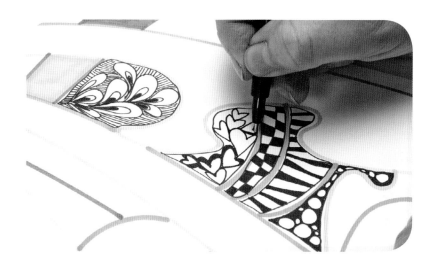

2 Fill the newly created spaces with colorful art patterns, lines and simple imagery. Use colored pencils and markers in addition to the black pen line art.

WHITE GEL PEN POPS

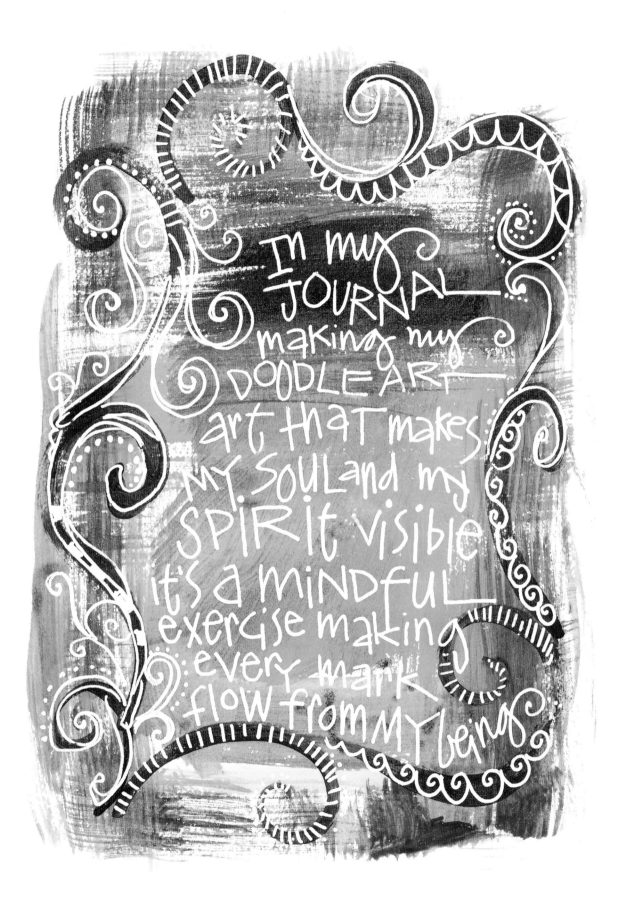

There really should be hundreds of samples of my white-pen doodling and lettering art here; you'll find white pen art in much of my work. I purchase these by the box because they are one of the top five staples in my supply stash. The white gel pen is so dramatic on dark backgrounds and often serves as the finishing touch on my journal and sketchbook pages and even in my canvas art. You should know, though, that the gel pen that I use is not waterproof and does wipe off while the ink is wet. As with any art supply, check the manufacturer's information for product features and directions.

Let the white gel pen become one of your favorites as well! Seek out various brands to see what works best for you. Experiment and try a few ideas, adding white pen marks into your own artwork, on painted pages and canvas. Use the white gel pen to:

- Create pictorial drawings of your favorite doodle subjects, like a scene or theme illustration.
- Get in a zen mood and draw simple, repetitive organic lines to cover a whole page.
- Draw outlines of geometric shapes and fill them in with patterns.
- Make playful little white doodles of hearts, flowers and stars.
- Add imaginative lettering with hand-drawn words.
- In your own handwriting use print or cursive to record thoughts, ideas and inspiration on dark colored backgrounds.
- Use the white pen to outline painted shapes or drawings.
- Accent images with clusters tiny white dots from the point of the pen, surrounding images or painted elements on the page.
- Work with just white on black, a glossy acrylic painted black background with only white lettering.
- Embellish handmade painted greeting cards with messages and sentiments.

Materials list

ACRYLIC-PAINTED BACKGROUND

WHITE GEL PEN (SUCH AS THE UNI-BALL SIGNO UM153)

PAGE BACKGROUNDS PAINTED WITH ACRYLIC OR WATERCOLOR PAINTS

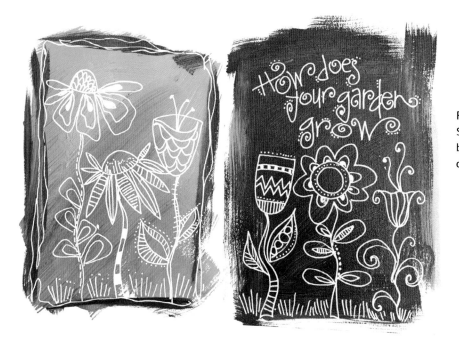

FOR UNEXPECTED DRAMA
Start with an acrylic painted background. Use a white gel pen to doodle as desired.

TO DOODLE-DO PROMPTS

Doodle art and lettering is stylized, loose, expressive art. Sometimes the most difficult part of making art is deciding what to create. Really stretch your creativity taking ordinary objects and transforming them into unique art works and lettering. Make everything and anything a theme or topic for your art. Think about how shapes and form can be transformed and abstracted to make repetitive lines and shapes. Use photos and computer searches for topics and inspirational images that spark ideas.

I make myself lists and am constantly brainstorming for those times that I have "artist's block." Make designated pages in your own journals and sketchbooks for personal inspiration resources. These 100 ideas can fill a whole journal. Are you up for that challenge? Here are some themes to get you started when you have absolutely no idea what to doodle!

NATURE INSPIRED

1. tree bark
2. fish scales
3. waves
4. river rocks
5. sand dunes
6. mountains
7. sticks and logs
8. stones and pebbles
9. birds
10. succulents
11. daisies
12. twigs and branches
13. pine trees
14. autumn leaves
15. stars
16. clouds
17. tropical leaves
18. seashells
19. marigolds
20. sunflowers
21. bugs
22. pods
23. animal prints
24. rain drops
25. butterflies, dragon flies and lady bugs

FOOD INSPIRED

1. strawberries
2. artichokes
3. corn on the cob
4. kiwi
5. bananas
6. broccoli
7. apples
8. green beans
9. red peppers
10. pickles
11. walnuts
12. birthday cake
13. pomegranate
14. lettuce
15. popcorn
16. citrus fruits
17. asparagus
18. pineapple
19. carrots
20. beets
21. mushrooms
22. onions
23. ginger root
24. pumpkin
25. peapods

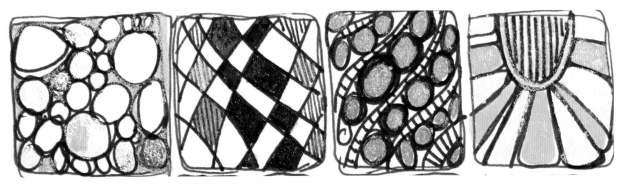

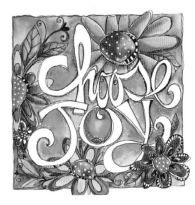

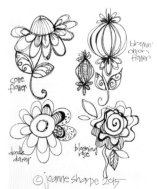

EVERYDAY INSPIRED

1. tea and coffee cups
2. silverware
3. handbags
4. shoes
5. necklaces
6. chains
7. zippers
8. picture frames
9. windows and shutters
10. fabric
11. holiday ornaments
12. doors
13. paintbrush
14. fabric
15. ribbons and yarn
16. teapot
17. keys
18. ice cream sundae
19. potted plant
20. a sponge

SHAPES AND FORMS

1. circles
2. rectangles
3. blocks
4. squares
5. paisley
6. teardrop
7. triangle
8. zig zag
9. scallop
10. ruffle
11. hexagon
12. honeycomb
13. heart
14. cone
15. egg

WORDS AND PHRASES TO DOODLE LETTER

1. create
2. inspire
3. believe
4. transform
5. explore
6. doodle
7. whimsical
8. imagination
9. peace
10. spirit
11. make it happen
12. all is well
13. you are loved
14. it's all good
15. shine your light

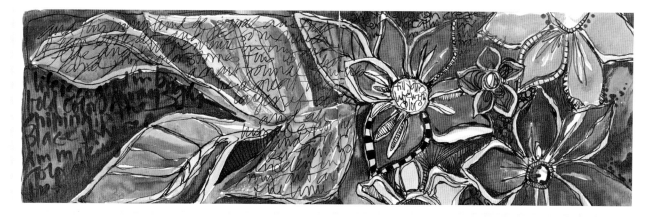

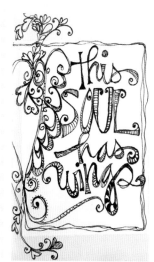

INDEX

ABOUT THE AUTHOR

Joanne Sharpe is an energetic, whimsical artist dedicated to empowering women to embrace their own creativity through online classes as well as national and international workshops that explore journaling, lettering, textiles and mixed media art. She is the author of the bestselling book The Art of Whimsical Lettering, named an Amazon's Editor's Pick for the Best Craft Book of 2014. Joanne is proud to be a BERNINA Artisan Ambassador, sharing her love of thread and fabric with an audience eager to learn how to bring these expressive media into their own artwork. Look for her second book, The Art of Whimsical Stitching, a colorful handbook of ideas and techniques for playful art sewing. Get into the coloring groove with her interactive, playful coloring book, The Art of Whimsical Living. Joanne resides in Rochester, New York, with her very supportive husband, is the mom to a daughter and three sons, and is a first time grandma to a precious baby girl. Follow all Joanne's artful adventures at: joannesharpe.com.

ACKNOWLEDGMENTS

Big thanks and gratitude to my F+W team for believing in me in every step of way and appreciating my high energy and crazy ideas:

- To my editor Kristy Conlin for your friendship and gentle lead giving me the freedom to create the book I envisioned.
- Tonia Jenny, for your direction, cheerleading, accessibility and guidance.
- Jamie Markle for the high five, simply stated "approved!"

- Amy Jones for organization and laughter and keeping me on track from the trainwreck.
- Jeanine Stein whose kindness, support and confidence in me energizes my creative soul.
- A special thanks to Sara Domville, for her encouragement and wisdom providing an epiphany for my potential as an artist and author.

a content + ecommerce company

Other fine North Light Books are available from your favorite bookstore, art supply store or online supplier. Visit our website at fwcommunity.com.

21 20 19 18 17 5 4 3 2 1

ISBN 13: 978-1-4403-4733-7

Editor: Kristy Conlin
Designers: Breanna Loebach, Brianna Scharstein
Photographers: Christine Polomsky, Al Parrish
Production coordinator: Jennifer Bass

Distributed in Canada by Fraser Direct
100 Armstrong Avenue
Georgetown, ON, Canada L7G 5S4
Tel: (905) 877-4411

Distributed in the U.K. and Europe
by F&W Media International, LTD
Brunel House, Forde Close, Newton Abbot, TQ12 4PU, UK
Tel: (+44) 1626 323200,
Fax: (+44) 1626 323319
Email: enquiries@fwmedia.com

IDEAS. INSTRUCTION. INSPIRATION.

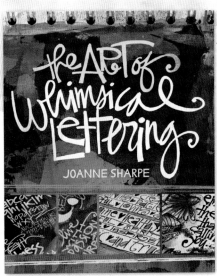

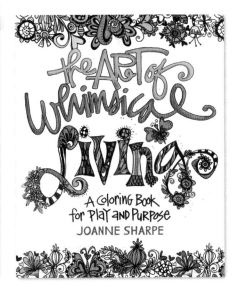

These and other fine North Light products are available at your favorite art & craft retailer, bookstore or online supplier. Visit our websites at artistsnetwork.com and artistsnetwork.tv.

Follow North Light Books for the latest news, free wallpapers, free demos and chances to win FREE BOOKS!

GET YOUR ART
IN PRINT

Visit CreateMixedMedia.com for up-to-date information on Incite and other North Light competitions.